Digital Food Photography

Lou Manna
with Bill Moss

COURSE TECHNOLOGY
CENGAGE Learning™

Australia • Brazil • Japan • Korea • Mexico • Singapore • Spain • United Kingdom • United States

COURSE TECHNOLOGY
CENGAGE Learning™

Digital Food Photography
Lou Manna

Publisher and General Manager, Course Technology, Cengage Learning PTR: Stacy L. Hiquet

Associate Director of Marketing: Sarah O'Donnell

Manager of Editorial Services: Heather Talbot

Marketing Manager: Heather Hurley

Acquisitions Editor: Megan Belanger

Senior Editor: Mark Garvey

Marketing Coordinator: Jordan Casey

Development/Project/Copy Editor: Kate Shoup Welsh

Technical Reviewer: Al Francekevich

Course Technology, Cengage Learning PTR Editorial Services Coordinator: Elizabeth Furbish

Interior Layout Tech: Shawn Morningstar

Cover Designer: Mike Tanamachi

Indexer: Kelly Talbot

Proofreader: Sean Medlock

For Lou Manna:

Associate Editor: Kathy Stromsland

Project Coordinator: Joan O'Brien

Designer: Loredana Sangiuliano

All trademarks are the property of their respective owners.

All photos by Lou Manna.

Important: Course Technology, Cengage Learning PTR cannot provide software support. Please contact the appropriate software manufacturer's technical support line or Web site for assistance.

Course Technology, Cengage Learning PTR and the author have attempted throughout this book to distinguish proprietary trademarks from descriptive terms by following the capitalization style used by the manufacturer.

For product information and technology assistance, contact us at **Cengage Learning Customer & Sales Support, 1-800-354-9706**

For permission to use material from this text or product, submit all requests online at
www.cengage.com/permissions
Further permissions questions can be emailed to **permissionrequest@cengage.com**

Library of Congress Control Number: 2005924924

ISBN-13: 978-1-59200-820-9

ISBN-10: 1-59200-820-8

Course Technology
5191 Natorp Boulevard
Mason, OH 45040
USA

Cengage Learning is a leading provider of customized learning solutions with office locations around the globe, including Singapore, the United Kingdom, Australia, Mexico, Brazil, and Japan. Locate your local office at **international.cengage.com/region**

Cengage Learning products are represented in Canada by Nelson Education, Ltd.

To learn more about Course Technology, visit **www.cengage.com/coursetechnology**

Purchase any of our products at your local bookstore or at our preferred online store **www.ichapters.com**

Information contained in this book has been obtained by Course Technology, Cengage Learning PTR from sources believed to be reliable. However, because of the possibility of human or mechanical error by our sources, Course Technology, Cengage Learning PTR, or others, the Publisher does not guarantee the accuracy, adequacy, or completeness of any information and is not responsible for any errors or omissions or the results obtained from use of such information. Readers should be particularly aware of the fact that the Internet is an ever-changing entity. Some facts may have changed since this book went to press.

Educational facilities, companies, and organizations interested in multiple copies or licensing of this book should contact the publisher for quantity discount information. Training manuals, CD-ROMs, and portions of this book are also available individually or can be tailored for specific needs.

Printed in the United States of America
4 5 6 7 11 10 09

Dedication

To my mother, who has given me so much—especially great food.

To my father, who encouraged me to follow my passion.

To my uncle Ralph, who gave me my first SLR camera.

To my two sons, Austin and Christian, who are my pride and joy. I'm sure that someday they'll go beyond macaroni and cheese.

To Joan, who is the voice of reason in my career.

And finally to my family, friends, associates, and clients who've helped me and encouraged me along the way.

Acknowledgments

I wouldn't have been able to write this book without the incredible contributions from the following individuals:

❖ Bill Moss truly gathers no moss. Bill is an incredible friend and associate, a tireless individual without whose writing ability this book would never have been written. I wrote the entire book *with* Bill. Bill was able to take my words and thoughts and cohesively pull them together in organized, well thought out, grammatically correct sentences—something that I never realized was so hard to do. (Is that active or passive or a fragment?) He took notes I wrote at Starbucks, scribbled on the train, or jotted down in taxis and made sense out of them, transcribing them into the appropriate sections with my additional verbal explanations. During the endless meetings in which I tended to ramble on, Bill kept me focused on the topic at hand. He skillfully sifted, coordinated, rewrote and reedited, understood, translated, educated, and communicated. Oops, I almost forgot, we did drink an awful lot of coffee together. That was the key!

❖ Kathy Stromsland, Associate Editor, is my guardian angel. Kathy has been more than an Associate Editor and a great friend. You'll notice when you read this book the extent to which I stress the importance of organization. That's because I strive to be organized, but always fall short. She has kept me organized, well fed, focused, and has gently guided me through the arduous process of putting this book together. Kathy managed to always be there for me. In addition, she reviewed countless images, maintaining the same artistic vision as I have for the book. Without her valiant efforts, the typing, captioning, and identification of all the photos would have been impossible. Nights, weekends, anytime and all the time, Kathy was helping me make this dream come true.

❖ Joan O'Brien, Studio Manager, is the best. I'm convinced of that. The more I give her to do, the more she does without a complaint and with apparent ease. Joan has been my eagle eyes since 1991 and is truly the voice of reason in the studio. Her contribution to my successful career has been invaluable and I cherish all that she has done for me. She is truly wonderful. Thank you Joan for everything you do.

❖ Loredana Sangiuliano, Designer, gave my words and pictures life with her layout design. Her patience, understanding, creative eye, and flexibility were beyond belief. She worked weekends and nights, tirelessly coming up with artistic ways to convey my thoughts in a visual format —and that's not easy to do. The success of this book is due to her inspired design.

❖ Maria Ferrari's knowledge is invaluable. I have learned so many new things about Photoshop from her. She provided countless tips, technical information, and notes from the classes she gives about Photoshop. Without her guidance, I would not have been able to complete Chapter 8, "The Digital Spice: Retouching."

❖ Morgan Poor, Reid Nicholls, Ben Swanger, Brian Watterson, and Dave Evans are my wonderful and hard-working interns. They spent countless hours retouching photos, shooting behind the scenes, creating illustrations, and most importantly, keeping me well fed. They have kept me young and I've enjoyed their company, creativity, and zest for life and thirst for photographic knowledge.

❖ Helene DeLillo was so helpful in feeding me the bits and bytes that are in the technical chapters. She is an excellent communicator and such a wealth of information. Additionally, I was able to shoot all the photos about equipment in her studio on her vibrant red rug.

❖ When it comes to business, I defer to the pros, and Maria Janedis is just that. After years at top positions in the banking industry, she contributed her knowledge to Chapter 9, "Get Cooking and Make Some Money: Getting into the Business." Also, some of the valuable information in Chapter 9 is thanks to my associates Eugene Mopsik and Peter Dyson at ASMP. I am proud to have been a member of this wonderful organization for my entire professional career.

- Rick Kerr helped me wade through the murky waters of commercial printing. He provided me with so much information that I realized we could write a whole book about it.

- Jeremy Miller collaborated with Kathy Stromsland on Chapter 3, "Who's Digesting It: Advertising, Packaging, Public Relations, and the Media" by answering countless questions about the public-relations and advertising industries.

- All of his years of wisdom and talent were apparent in Al Francekevich's review of every chapter. I felt confident that he would catch any small imperfections and add his own views.

- Without Megan Belanger, Acquisitions Editor at Thomson Publishing, this book would not be a reality. She found me on the Internet, sent me an e-mail in November of 2004 asking if I was interested in writing this book, and the roller coaster ride began. Throughout the seven-month course of this endeavor, with over 500 e-mails, innumerable phone calls, patience, and wisdom, she guided me through this long and grueling process. It is Megan who has kept this project going and has seen it come to its fruition.

- Kate Shoup Welsh, Development Editor and Copy Editor, has done something remarkable. She has taken the copy that Bill and I wrote and helped form it into a cohesive book. Without her, what you are reading simply wouldn't be as wonderful as it turned out.

- As the deadline for this book approached rapidly, Book Designer Shawn Morningstar and I spent countless hours working out the details and fine-tuning the page designs until we came up with something we both liked. She was able to take Loredana's vision along with mine and combine them into the beautifully produced book that you see before you.

- Thank you to everyone at Thomson Publishing for helping to make my first book a success. I would like to send a special thanks to everyone listed in the credits.

Continued gratitude goes to the following:

- A heartfelt thanks to all of the stylists involved with this project, especially Diane Vezza, Brian Preston-Campbell, Matt Tuttle, Betty Barquin, Lynn Gagne, and Francesca Abbracciamento. They are all truly gifted individuals and it is always a pleasure to work with them.

- Thanks to all the chefs who created beautiful, delicious dishes, especially Momo Attaoui (whose gorgeous work appears on the cover), Jay Weinstein, Tina Marie Casaceli, Neil Murphy, Richard Leach, Wayne Harley Brachman, Robert Ubhaus, Ian Topper-Kapitan, and Marco Runanin.

- Thank you to my clients—especially Prita Wadhwani, Barbara Knudtson, Kimberly Humann, Diane Muhlfeld, and Mike Surabian—for their valuable advice and recommendations.

- I would like to send a special thanks to Gino Colangelo and Anya Grottel-Brown, who were instrumental in my becoming an Olympus Visionary Photographer.

- I am so grateful to my associates at Olympus—especially John Knaur, Rich Pelkowski, Chris Sluka, and Lou Desiderio—for their support and for having such a great product.

- A debt of gratitude goes out to my faithful friends at Adorama Camera, where I bought my first 1-megapixel professional SLR digital camera for a mere $15,000 about 10 years ago! They always give me the best prices and advice on current equipment. Special thanks to Peter Lipschutz and Julio Figueroa.

A final thanks to anyone that I may have missed in these acknowledgements. Your omission was purely unintentional!

About the Author

Lou Manna is an award-winning Olympus Visionary photographer. He has more than 30 years of experience working with chefs, photographing cookbooks, and shooting food for publications such as *Wine Enthusiast, Food Arts*, and *The New York Times*, where he worked as a photojournalist from 1975 to 1990. Manna is an early adopter of digital technology—he has been shooting digitally for more than 10 years. Manna has worked on location and in his studio with famous chefs such as Michael Lomonaco, Jacques Pepin, Bobby Flay, Lidia Bastianich, and Emeril Lagasse. He has appeared on ABC TV's *World of Photography* and on the Food Network, and has lectured at the French Culinary Institute. Manna's award-winning photos have appeared in more than 30 cookbooks, including Dr. Phil's *The Ultimate Weight Solution Cookbook*, Jacques Torres's *Dessert Circus*, Pierre Franey's *Cuisine Rapide*, and Arthur Hettich's *The Four Star Kitchen*. He recently provided a number of shots for *The New York Times*'s bestsellers *America 24/7* and *New York 24/7*.

Contents

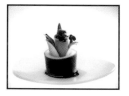

4 Who's Doing the Cooking: Working with Food Stylists 83

5 **Prop Styling: Who's Doing the Shopping?** **125**

6 **Grabbing Your Attention: Composition** **159**

7 The Recipe for Light 191

8 The Digital Spice: Retouching 231

9 Get Cooking and Make Some Money: Getting into the Business 271

Index 289

Introduction

The Saliva Factor: Let's Cook Up Some Food Photos!

The job of a food photographer is to elicit the same mouth-watering reaction as the smell of freshly baked bread or the taste of a perfectly grilled steak. A great food photograph can convey feelings of warmth, awaken fond memories, conjure up fantasies, or just plain make you hungry. It can send crowds flocking to a new restaurant or boost the sales of a food magazine. Capturing that perfect image requires a creative eye, finesse, a sense of style, and photographic skill.

In the old days, food photographers almost always shot from overhead because that was the way people were used to seeing their food—looking down on the plate. These photographs were rigid in nature, with utensils and props placed in the positions at which they were traditionally found on the table. Large-format view cameras were used to capture all the details. Because photographers used hot tungsten lights for illumination, the food spoiled and melted quickly! Much of the photography was in black-and-white because most publications and books were printed that way.

As time passed, we began to see changes in lighting and mood. Warm and romantic lighting was in vogue for quite some time, though the pictures were still shot primarily from overhead angles. The style was "the more props and accessories, the better." Later, slightly lower angles and a simple Spartan look became the trend, with a bit of earthiness and softness. Even so, the pictures looked staged. I have been there and done all that!

My career began in 1975, shooting for *The New York Times*. I photographed food in black-and-white, and making it look appetizing was what I did best. I did it in spite of the poor reproduction of newsprint. My subsequent experience shooting for magazines, public relations firms, advertising agencies, restaurants and cooking schools, cookbook authors, and chefs has been invaluable in understanding changes in food photography. Having made the switch from film to digital more than 10 years ago, I was ahead of the technological curve. I learned very early that digital technology gives the photographer the opportunity to review shots instantly, make appropriate adjustments, and achieve superior results.

Today, a simple, clean, fresh, natural, and light approach is the trend in food photography. We see the imperfections in the food, along with the use of selective focus, tilted plates, and extreme close-ups with fewer props. These techniques have become the industry standard. At the same time, there has been a marked increase in the need for high quality digital food photography—in packaging, advertising, cookbooks, and the Internet.

Old style

New style

A complete understanding of basic principles is essential in any genre of photography—be it sports, fashion, product, or food. My goal is to help you develop your own recipe for success in food photography. To that end, this book examines studio and location shooting, lighting, composition, food and prop styling, retouching, and much more. Along the way, you'll learn how digital photography combines teamwork, creativity, and technology.

With this book, I want to show you how to make money doing something you love. Oh, by the way, eating the end result is a big plus!

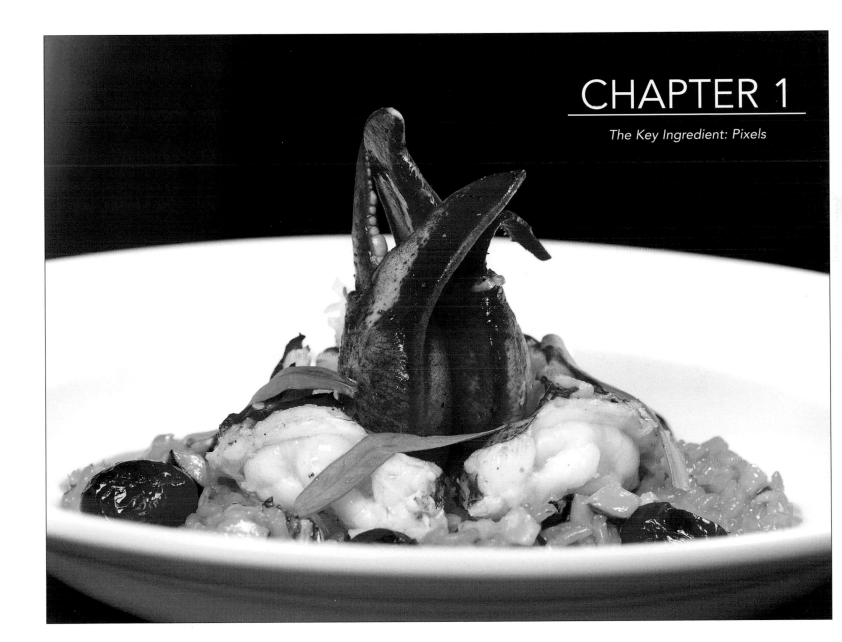

CHAPTER 1

The Key Ingredient: Pixels

The Way It Was: Working with Film

During almost every commercial photography assignment in my pre-digital days, one of my major concerns was whether I got the shot before the set was dismantled. No matter how carefully I planned or executed a shot, a wide range of technical problems could arise that were out of my control.

Even for a professional photographer, it is very hard to see an image in a large-format, 8x10 view camera because it is upside-down and very dark. Not only was it very hard to view the image, but because of variations in emulsion from one batch of film to another, I would have to test the film for color balance and fidelity before shooting, and make fine adjustments with filters. That meant the exposure could easily have been wrong. Also, parts of the image could have been slightly out of focus, although they were not intended to be that way. There might have been reflections you couldn't see due to lack of detail in Polaroid test shots or on the ground glass of the camera. There might have been dust or scratches on the film. In a few instances, the lab ruined the film and we had to reshoot entire jobs. And sometimes, clients simply changed their minds and rejected images that had been previously approved.

The solution was to overshoot—that is, to take pictures from many different angles and exposures—to cover myself and to have a wide selection of images to choose from. It was time-consuming and expensive in terms of film, processing, and setting up, not to mention cleaning film holders in the darkroom, loading sheet film, and so on.

note

In food photography, food can quickly lose its visual appeal under the hot lights. We regularly use stand-in food for focusing and composition, and then bring in the star dish after all the technical aspects have been determined. Only a few minutes of shooting and bracketing might be available before the star dish fades as well. Ice cream might look great for a minute or two, but it quickly becomes a mess. Shooting Polaroids was necessary for composition and lighting, but it cut into the time available for taking the "real" shots.

The Way It Was: Working with Polaroid

As an artist and professional photographer, one of the most important skills I have is the ability to previsualize an image. I can see vividly in my head what the final image will look like before I ever take the picture. Taking test shots on Polaroid film, which was the practice in the days before digital photography, helped me give clients an idea of what the final image would look like, but it was not a foolproof solution. Although Polaroid prints can show composition and lighting, the one-minute chemical process cannot reproduce the color and clarity that can be captured on film. Also, it was very hard to explain to clients how the final image would differ from the Polaroid.

A 4×5 Polaroid test shot taken in my studio almost 20 years ago. Polaroids were useful for lighting and composition, but were limited in their ability to accurately portray colors and details in the shadows.

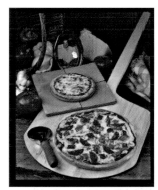

A 4×5 transparency of the final shot from the same setup had much more color and shadow detail.

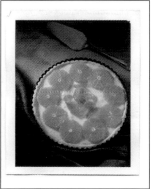

A 4×5 Polaroid test shot gave us an idea of what the shot would look like.

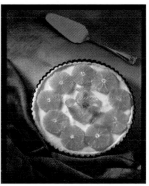

A 4×5 transparency of the final shot had much more color and shadow detail.

The Way It Is: Working with Digital

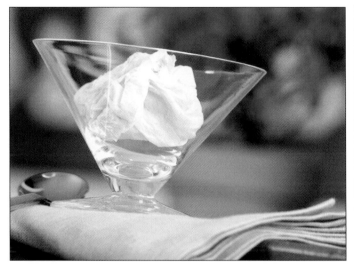
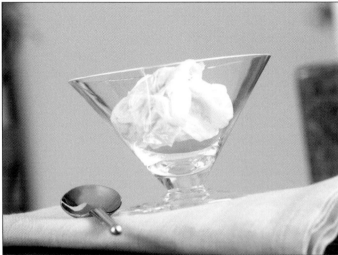

A crumpled paper napkin used as a stand-in for sorbet enables the photographer and clients to evaluate a variety of backgrounds and camera angles.

On the set, clients can view the test shots on a flat-screen monitor.

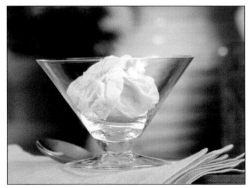

The final test shot of the "stand-in" with approved background and props.

The photographer and clients agree on a final shot.

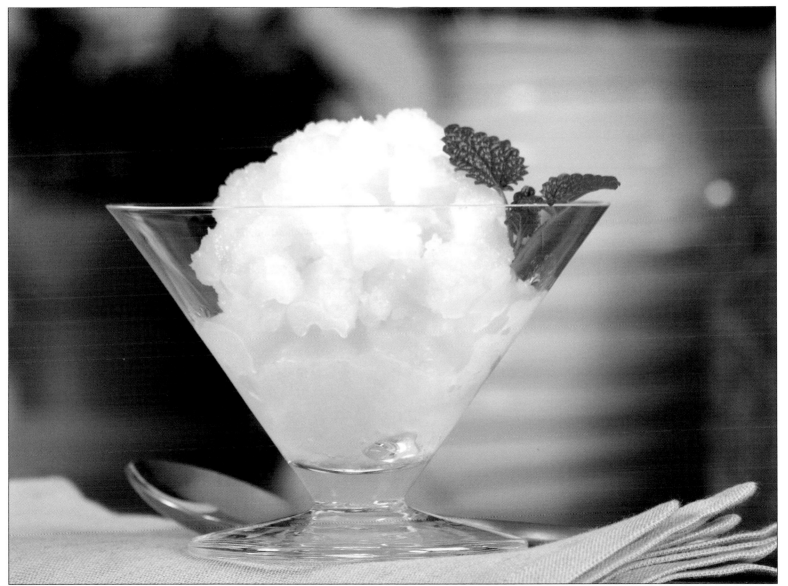

Final shot of sorbet and garnish.

Because I know what the final images will look like, differences between the test shots and the final shots are never as critical to me as they are to clients, who tend to be very literal in their interpretation of what they see. In fact, I can recall a number of cases in which a client fell in love with a Polaroid image, and it was a problem when the film image, generally a large-format color transparency, did not exactly duplicate the Polaroid. This proved to me that if clients like what they see, then that is what they want. Of course, in commercial photography, it's all about satisfying the client, and I knew instinctively that I had to find a way to get clients more in touch with the creative process.

The original photograph of the Marriott Marquis Broadway Lounge taken with a four-megapixel Olympus E-10 camera.

That's why, more than 20 years ago, I began setting up a small television camera next to my film camera to help my clients understand the process of creating a food image. Clients could watch a monitor and get a photographer's eye view of a shot's lighting and composition, the props, and their placement. Even this was not a perfect solution, however, because although I constantly explained that the television image was not at exactly the same angle as the film camera, some clients just didn't get it. The good news was that using the TV camera saved a lot of money in Polaroid film and helped get clients more involved in my previsualization process. I was able to show them what worked and what didn't work in a photograph through the immediacy of the video image. Clients were happier because they always got what they wanted.

Then, in 1995, everything changed when I "went digital." Even though I knew that, at the time, digital image quality was not as good as film for larger reproductions, the immediacy and versatility of digital photography proved to be satisfactory for my newspaper and Web work. I was very excited by this, and embraced the new technology with fervor. My first digital camera, a whopping one-megapixel model, set me back $15,000, not including all the computer hardware, software, and the thermal dye sublimation printer I needed to purchase to support the format. In all, I spent more than $60,000 on digital hardware and software.

The Digital Age

Digital technology has advanced quickly. Around the turn of the century, I actually stopped using film unless the client requested it. Film just doesn't make sense! The image quality I can achieve with modern digital cameras is more than adequate for almost any reproduction. In 2002, a photo I took for the New York Marriott Marquis Hotel with a five-megapixel Olympus E-10 was blown up for use on a 60×80-foot billboard in Times Square—and it looked great!

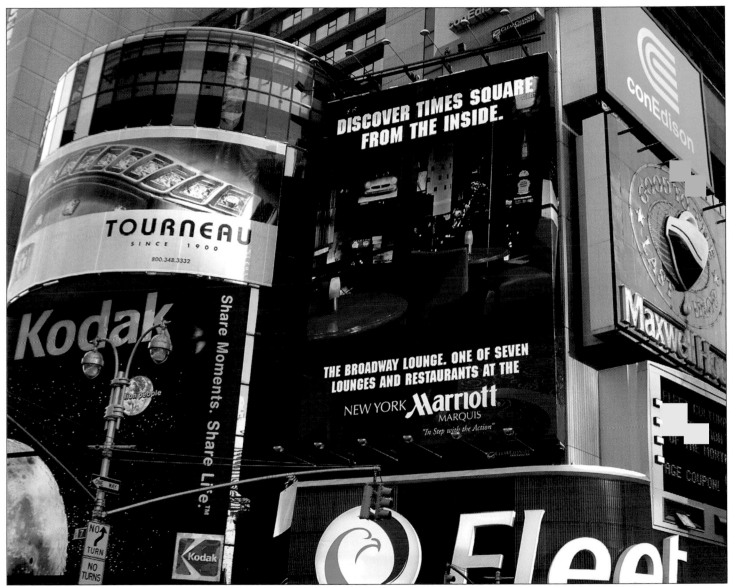

This image was cropped from the center portion of the original photo and used for the Marriott Marquis Times Square billboard.

In fact, with many of today's professional digital cameras, image quality is superior to film. And for many professional photographers, digital SLRs and digital camera backs have replaced the need for large-view cameras.

Today, the practice in my studio is to have my digital camera connected to a 37-inch television monitor that has been calibrated for color. Clients can view the images on this large screen, and adjustments to photographs can be made easily. Teamwork is realized in a way that cannot be achieved with film. After capturing a series of images, I head straight to my computer with my Compact Flash card—my "reusable roll of film"—in hand, and open the images in Adobe Photoshop for viewing, editing, and retouching. I no longer have to send film to the lab and wait…and wait…and wait…and wonder…and hope…that I "got the shot."

The Digital Process

A digital camera uses a sensor, such as a CCD (Charge Coupled Device) or a CMOS (pronounced *sea-moss* and short for Complementary Metal Oxide Semiconductor), to capture images electronically. These sensors contain grid-like fields of extremely small cells called *pixels*, short for *PICture ELements*. A pixel is the smallest element of a digital image, comparable to the grain on film. Don't be concerned by these terms; they simply refer to technologies that enable a better way to capture an image. You still have to be a good *photographer* to properly compose a subject, light it, and get the shot, just as you did in the old days with film.

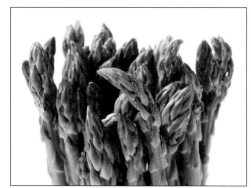

Photo taken with a 5-megapixel camera showing the detail in asparagus tips.

A portion of same photo, which has been magnified 1,200 times to reveal how the pixels make up the image.

Digital Advantage

As mentioned, one of the most significant advantages digital photography has over film is that digital provides instant feedback on every image you shoot. It also brings the photographer, the food and prop stylists, and the clients closer together in the creative process, while reducing the time and expense of a shoot.

In the studio, digital images are instantly available on a monitor or video screen. I can set up a slide show so that clients and I can review an entire series of images on-site, and pick the ones to use as final photographs. If the client is not present at the shoot, low-resolution versions of the images can be sent via e-mail or can be uploaded to a Web site for review. I can even set up a Web page that can display multiple images. These online digital contact sheets provide an expedited editing process and closer collaboration with clients. This certainly beats the old working method of sending transparencies via messenger or over-night delivery and waiting hours or days for feedback and approval!

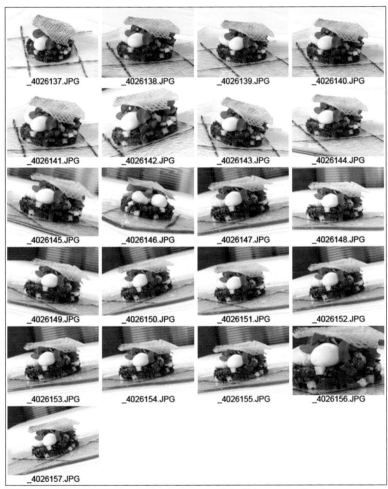

This contact sheet shows shots of tuna tartare with buffalo mozzarella taken at various angles and distances. Each image is labeled with an identifying file number.

Imagine how exciting the creative process is when the conversation goes like this:

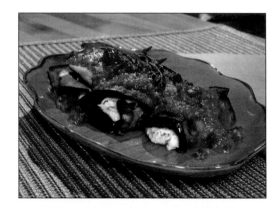

"What do you think?"

In this first shot for Barilla, I started with a very bright light source to mimic sunlight and create an outdoor feeling. The eggplant rolls prepared by the food stylist did not show enough ricotta filling. There was too much sauce, and the position of the thyme was not right. The prop stylist chose a placemat that had too much texture, and was too close in color to the wooden surface of the table.

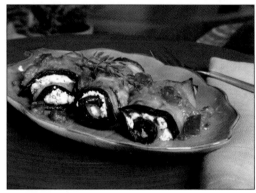

"Let me try this—how about this one?"

I lowered the angle of the camera to add depth to the image, and softened the lighting to reduce the highlights because I felt that bright light made the eggplant look greasy. I added mirrors to give more detail to the front of the eggplant rolls. The food stylist reduced the amount of sauce and remade the rolls to show more filling. The prop stylist substituted a red placemat to create more contrast, and added a fork and potted herbs to the background to enhance the mood.

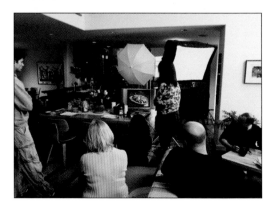

"Give me a minute—it's almost there."

Taking advantage of the instant feedback provided by digital photography, the creative team and photographer worked together on the set to get the perfect shot.

"It's just what I wanted!"

The final shot. I slightly repositioned the camera and added another mirror to get an extra highlight. I also reduced the depth of field to throw the background out of focus. The food stylist made a final adjustment to the positions of the eggplant rolls and the thyme. The prop stylist changed the angle of the napkin and the fork, and added more background elements to complete the space.

You know you got the shot when the client says…

"That's the one!"

"I love it!"

"Great lighting!"

"It's perfect!"

"Wow, that's it! You got it!"

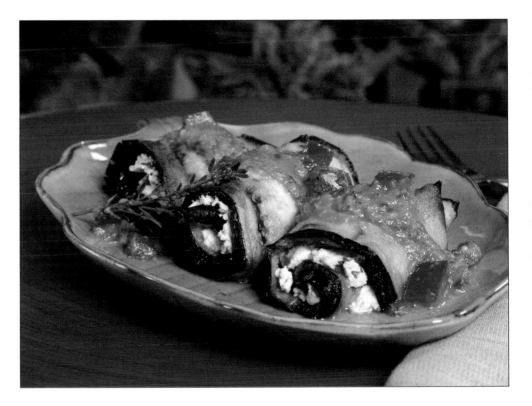

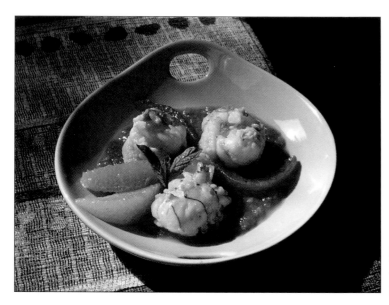

Scampi photographed in harsh sunlight.
The client wanted natural light to create an outdoor mood.
This reference shot was taken to record the dish, natural
lighting, dark shadows, and background.

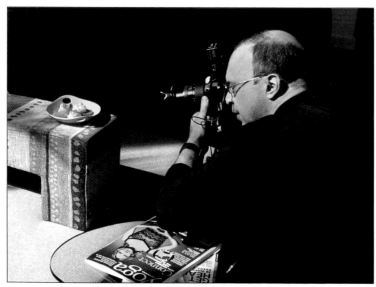

It's a challenge to compensate for the sunlight.

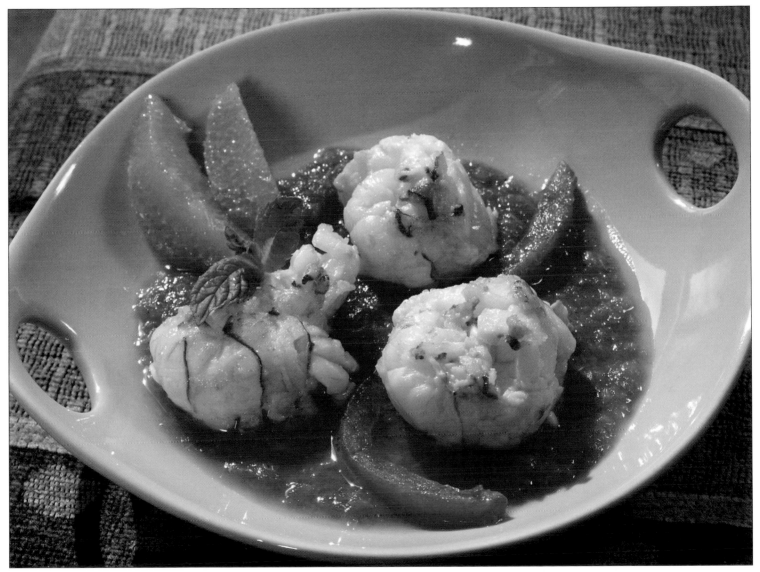

Using supplemental light, reflectors, and mirrors brings out the highlights in the dish and details in the shadows, while still taking advantage of the natural sunlight.

When shooting digitally, you don't have to use different types of film such as daylight, tungsten, transparency, or negative. You also don't have to set the ISO speeds or attach color correction filters, because the ability to change and adjust all these settings is included in the camera's software. Even if you miscalculate, you can correct a wide range of image details on the computer, especially if you shoot in the RAW format.

Digital provides the photographer more latitude and creative freedom than ever before. As a professional, it is a great advantage for me to have total control from start to finish, because in addition to shooting the images, I can also prepare them for reproduction. Digital gives me the ability to create my own color separations, prints, and copies that are as good as the originals—and charge for these services! This saves me time and saves my clients money by removing labs and other external vendors from the process. In fact, most labs that have not converted to digital technology have gone out of business. What a time-saving, cost-effective, and high-quality process digital photography has proven to be!

Digital Challenges

With all of its advantages, digital technology does present some challenges. For example, shooting digitally is comparable to shooting slide or color transparency film, which is less forgiving than print film for exposure latitude. For this reason, it is best to use a softer light source when shooting digitally so that there is detail in the highlights and shadows. Just be careful not to overexpose the highlights!

In addition, while digital camera technology continues to improve, there is a short delay between the time you press the shutter and the time at which the image is captured—although this has become less of a factor of late. Of course, in food photography, the delay is much less of a concern because the subject is almost always a still life. But in sports and action photography (and to some extent in portrait photography), this can be a major issue. Like a quarterback leading a receiver on a pass play, the photographer must be able to anticipate the subject's motion and position fractions of a second in advance. That said, although digital cameras lack the physical response of a film camera's shutter release, over time you get used to the feeling of taking a shot and holding the camera steady to compensate for the delay.

tip

I get the electronics in my camera ready by lightly tapping the shutter release button for a few seconds before I plan to take a picture.

Finally, as digital files become bigger because of higher-resolution cameras, archiving and cataloging libraries of images becomes more of a problem. Sure, it's great to be able to take more pictures and make unlimited backup copies, but where do you keep them all?

Backup Storage/Archiving

Originally, archiving images on CDs was the preferred storage method. Now, DVDs are becoming more popular because they can store six to seven times as much data as a CD. For example, double-sided, double-layered DVDs store up to approximately 17GB. In addition, DVDs provide more data protection than CDs because their reflective coating is sandwiched between two polycarbonate layers, which protect the media from scratches. DVDs are also faster than CDs for data access. For photographers who need extensive storage, high-capacity external hard drives are available, and many professionals are using multiple hard drives and RAID storage devices. You can never have too much storage. Your hard drive will fill up quickly!

Now that you've seen the digital advantage, let's get down to the nitty-gritty and talk *in detail* about the cutting-edge tools of the trade.

I love shooting digitally. It provides the freedom and versatility to work with clients in a creative atmosphere I have never been able to experience before. Digital food photography is a beautiful thing!

Since the mid 1990s, digital camera technology has advanced very quickly. New cameras and features are continually released. Identifying the right digital camera for you can be challenging because there are so many options from which to choose. If you are buying a professional digital camera, there are several key features to look for. In addition, to get the most out of your investment, you'll need to understand certain technical information. Take some time before you purchase to think about how you will use your camera and photos. This will help you determine the features you need most, and zero in on the camera that will serve you best.

In this chapter, you'll find out what aspects you need to consider when selecting a digital camera and accessories, as well as some basic information about understanding and using your digital camera. For information about other elements of your digital workstation, see Chapter 8, "The Digital Spice: Retouching."

note

If you already have a digital camera, consider reading this chapter anyway; doing so will help give you a better understanding of how it works.

Selecting a Digital Camera and Accessories

A professional digital camera is a major purchase, and your ability to use it effectively will be one of the most important factors in your success as a food photographer. Ask yourself the following questions before you purchase a camera. The answers will help you identify the camera and features that are best for you.

tip

Although a camera may cost a few dollars more at a retail store, a trustworthy dealer is worth his weight in gold. You'll get advice and service for years down the road. Sure, you can get good deals purchasing a camera by mail order or over the Internet, but there is no substitute for the experience of holding a camera in your hands and getting a good feel for its controls and settings.

❖ **What is my price range?** Digital camera prices vary depending on their features and capabilities. Professional cameras start around $1,000 and run up to the high $30,000s. Good cameras for the digital enthusiast range in price from $1,000 to $6,000. Knowing your price range will help you narrow the field and decide which features you need most. Of course, the price you can afford greatly depends on how often you use the camera. If you use it daily for professional work, the return on your investment will be quick.

tip

Bear in mind that when you shoot digitally, you will no longer have to pay for film and processing. That means you can invest more money in the camera and accessories!

❖ **How much camera do I really need?** Whether you need some specific features—such as close-focusing, an extra-large LCD viewfinder, or zoom lenses—depends on whether you will be using your camera only for studio work, or also for location shoots such as press conferences and cooking competitions. Unfortunately, people often buy much more powerful cameras than they really need, thinking they might use the extra features somewhere down the road. The fact is, however, that these cameras are loaded with bells and whistles that will rarely ever be used. A much better approach is to buy a camera that is just good enough for what you need today. Digital technology is advancing so quickly, with prices dropping just as fast, that by the time you've gained some experience and decide you're ready for more advanced features, you may be in the market for a better camera—possibly at a lower price than you paid for your first one!

tip

One of the most important considerations when deciding whether to buy a particular camera is whether it is comfortable to hold and intuitive to use. You really have to feel as if you want to use it every day. As a food photographer, you are an artist, and your camera is an extension of your eyes and hands. Test a camera thoroughly before purchasing it to make sure the controls and menus are easy to use for your style of shooting.

❖ **Do I need a new set of lenses?** Do I need a zoom lens? Whenever you evaluate a camera, be sure to consider what lenses are available. Be aware, too, of the f-stops and the focusing range of the lens. Most digital SLR cameras come with a standard 28–80mm zoom lens. A standard complement of lenses includes a wide-angle lens, a normal lens, and a telephoto lens. You will also need a polarizing filter, which helps to reduce reflections and enhance certain colors in natural light. If you already own many lenses from a particular camera manufacturer, start with one of that manufacturer's digital cameras.

tip

Digital lenses are better for use on digital cameras, because they control the path of the image and direct it straight into the camera sensor for better image resolution. I learned this when I started using Olympus digital cameras, which feature wonderful digital Zuiko lenses.

tip

It is critical to keep your lenses clean with a soft lens cloth. Be especially careful when cleaning your lenses in the kitchen or studio—food or other substances on the cloth can scratch your lens! It's also a great idea to purchase a clear protective filter for the front of your lens. It can be replaced easily and inexpensively if scratched, and you won't damage the front lens element.

❖ **What accessories do I need?** In addition to the lenses mentioned in the preceding bullet, your basic kit should also include a tripod, batteries, portable flashes with external battery packs, and digital storage media.

❖ **Do I need a macro feature to take photographs of objects at very close range?** For serious food photography, you will definitely need a macro lens or a camera with the ability to focus at very close distances. Fixed and zoom lenses vary in these capabilities, or there may be a special macro lens attachment for your camera.

❖ **What are my power requirements?** Will you always use batteries, or do you expect to work near a power outlet? Because many digital cameras have proprietary batteries that work only with that specific camera, it is important to purchase at least one extra battery and an external charger. It is easy to forget to charge your batteries, but if you do not have power, you won't get the shot! For this reason, I always carry several extra batteries and make sure they are fully charged.

tip

If you plan to shoot overseas, be aware of what type of power will be available so that you can charge your batteries while you're abroad. Many travel stores sell power converters that work very well.

tip

Batteries represent about one-third of a camera's weight, so be sure to compare different models with the batteries loaded. Often, batteries are not installed in the retailer's display units, and the difference can be surprising!

❖ **Where will I be taking my pictures—on location or in a studio?** Will I have control over the light? As a food photographer, you may encounter many situations where you will not be allowed to use a flash. For this reason, you should consider purchasing a digital camera designed for shooting in low-light situations. These cameras typically have ISO settings of 100–6400, and sometimes higher, which enables you to get a shot with no flash. Keep in mind, however, that if you shoot at these higher ISOs, your images will be grainier and of lesser quality.

❖ **Do I need an external flash?** An external flash is essential to good food photography. That's because built-in camera flashes flatten the subject, causing it to appear to have less depth and shape. These built-in flashes just don't have enough power, so the light they provide falls off drastically and fails to properly illuminate objects in the background. Direct flash creates awful shadows and doesn't bring out the texture or color of food. See Chapter 7, "The Recipe for Light," for more information.

tip

Although many digital cameras have a built-in flash, you should not use it for your food photography! Make sure you shut the camera's flash off. Sometimes, after you have shut the camera off and turned it back on again, it will default back to the built-in flash, so be sure to recheck the setting.

❖ **In what weather conditions will I be shooting?** Do you need a waterproof camera? Will you be taking pictures in high-heat conditions or in below-freezing temperatures? Some digital cameras are designed for extreme weather conditions. For example, you can use waterproof digital cameras on a boat or in the rain without worry. As an on-location food photographer, you might have to shoot outdoors in the winter, inside a walk-in freezer, or near the open flame of a stove or barbeque. For this reason, you should be aware of what the camera's body is made of. You certainly don't want to scorch or mar the finish—not to mention damage its lens or sensitive electronics—by exposing it to extreme cold or high heat.

tip

For serious photography, consider cameras with metal bodies, such as aluminum, steel, magnesium alloy, or titanium. They are more rugged and sturdier than plastic.

❖ What am I going to do with my photographs? Do you plan to make your own prints? If so, how big do you need them to be? Bigger prints require a higher-megapixel camera for the best reproduction quality. On the other hand, if you will primarily be posting your pictures on a Web site or sending them to newspapers, lower-resolution images are just fine.

tip

Digital cameras are classified by the megapixel count in the sensor. For food photography, you should have at least a 5-megapixel camera. If you are going to need gallery-quality 11×14-inch prints, or if your pictures will be used in large in-store displays or billboards, you should purchase a digital camera with at least 8 megapixels.

Understanding and Using Your Digital Camera

Each digital camera has a different design and controls, so features on your camera might be slightly different from those described here. For example, some cameras have a delete button, while other cameras have a menu item for deleting photographs. If you are unsure of a feature, refer to the manual that came with your camera. In fact, have your digital camera's manual on hand while going through this section. It's my experience that the "Quick Start" guide does not provide sufficient information about the advanced features of most cameras.

Resolution

The resolution of a digital camera is measured in pixels. A *pixel* is the smallest element of a digital image. Resolution is a combination of the relative size of each pixel and how many there are on the camera's sensor, or chip. The sensor captures red, green, and blue pixels, and then processes the information into a full-color photograph. As the pixel count increases, so does the amount of information in a picture. A 5-megapixel camera can capture 5,000,000 pixels. Today's professional digital cameras range from 5 megapixels to 24 megapixels.

note

Pixels are also used to measure the resolution of computer screens and printers.

The following pictures illustrate how the red, green, and blue pixels are combined to form a full-color image.

Photograph of an apple on a white background taken with a 5-megapixel camera.

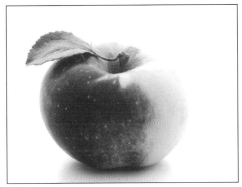

Red pixel components.

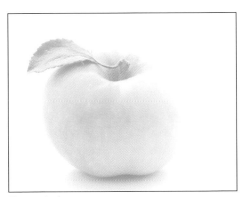

Green pixel components.

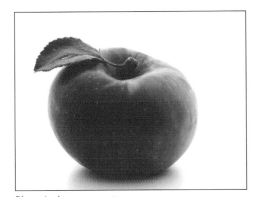

Blue pixel components.

Optical and Digital Zoom

If you plan to take lots of photos from a distance, it's important that you look at a camera's zooming capabilities. An *optical zoom lens* is a variable focal length lens. It actually changes its angles of view from a wide angle to a telephoto view. Zoom lenses are usually identified by their telephoto power—2x, 3x, and so on. The power is determined by dividing the lens's maximum focal length by its minimum focal length. For example, a lens with focal lengths ranging from 20mm to 100mm would be a 5x zoom lens.

Take the time to look through the lens of the camera you are purchasing to make sure the optical zooming capability is what you want. Also of particular importance with food photography is how close the lens focuses to the subject. If it does not focus very close—for example, at a distance of one foot—then I recommend that you purchase a separate macro lens or macro attachment that will focus down to one inch.

Most digital cameras also have a digital zoom feature. With digital zoom, the camera's software enlarges the center portion of the image and crops it digitally. This is nice in a pinch, but the image's quality goes down when you use this feature. I'd rather make cropping decisions later, when retouching photos on the computer.

LCDs: The Digital Viewfinder

One of the most enjoyable features of digital photography is the ability to see immediately on the camera's LCD (liquid crystal display) the pictures you have taken. With some digital cameras, you can also preview your photo on the LCD while preparing to take the picture. This allows you to see what your image will look like without having to peer through the viewfinder. The LCD also lets you show your photos to your friends, family, or colleagues. Cameras typically offer various settings for the size and zooming capabilities of the image on the LCD. Some cameras even enable you to run a slideshow on the LCD.

tip

When selecting a digital camera, make sure the LCD is big enough for your personal taste. Newer cameras have bigger screens that are brighter in sunlight and have a greater angle of view. Be aware, however, that this feature uses a lot of battery power.

You can customize the LCD viewing options on all professional cameras. I prefer to have the image pop up on the screen for five seconds after taking a shot. I can bring the image back up instantly on my Olympus EVOLT E-300, which automatically rotates it if I've shot vertically. I also zoom in up to 10x to quickly check focus and image quality. This camera also has a VIDEO OUT jack, to connect the camera directly to my studio TV monitor.

tip

There is a big difference between judging an image on the LCD and in the viewfinder. The LCD enables you to preview the image in two dimensions, and it gives you a good idea of what the final photo will look like by displaying the lighting and exposure on the screen.

Battery Options

All digital cameras require a lot of power to operate, so it's always important to have extra batteries with you. There are many types of batteries for digital cameras, including the following:

❖ **Proprietary batteries.** Many manufacturers have designed batteries that work only with their cameras to optimize performance and speed. I know that I am repeating myself, but it really is essential that you purchase an extra battery for these cameras. This is especially true if you are traveling or on location; you will probably not be able to find a spare on short notice.

❖ **AA batteries.** Many digital cameras can use the standard AA alkaline batteries available at almost any store around the world. Digital cameras vary in the number of AA batteries needed for operation. Although the availability of AA batteries makes them attractive, you should save them for your MP3 player! These are the worst batteries to use for photography. They don't last long and lack the "oomph" to run all the systems in a digital camera.

❖ **Rechargeable Nickel Metal Hydride (NiMH) batteries.** These rechargeable batteries are economical and easy to use, last longer than standard AA alkaline batteries, and have much more kick to them. That said, it can take up to 14 hours to recharge NiMH batteries in a standard charger. Fortunately, inexpensive "fast" chargers are available, which can do the job in 30 minutes to an hour. If you are traveling, be sure to take the charger with you!

❖ **Lithium batteries.** Lithium batteries are long-lasting and have about 4 5 times the power of standard AA alkalines. They cost a little more, but they are worth the power benefits. For my money, lithium batteries are definitely the way to go!

tip

Most digital cameras automatically power down if you have not taken a picture for a few minutes. If the camera turns itself off, you may need to reset it by using the on/off switch or by tapping the shutter button lightly. This "sleep setting" is often a customizable feature in your camera, which you can change. If you know you won't be using your camera for a while, turn it off to save power.

Digital Film: Storage Media

Instead of using film to store your photos, digital cameras use *storage media*. There are different types of media available for digital cameras. Some cameras—especially low-end cameras and super-compact cameras—use internal memory, which means the photos are stored in the camera itself. Others use removable memory cards, such as Compact Flash (CF) cards, SmartCards (SCs), and xD cards. Some cameras allow you to store images to more than one type of media.

note

A storage card is included when you buy most digital cameras, but they tend to be slow, low-capacity models. Plan to buy additional ones with more memory. They quickly pay for themselves!

The major physical difference between various types of digital storage media is that the electronic contacts on xDs and SCs are exposed and vulnerable to damage, while the contacts on CF cards are recessed and protected. In addition, there are differences in their size and ability to quickly write, read, and download data. The speed of digital media depends on the size of the pictures stored on it and the type of memory card used. When purchasing media, be aware of the card's capacity as well as its writing speed. For example, professional Compact Flash cards that are designed for specific camera models enable you to take pictures more quickly because they have a special buffer in the card to speed up shooting.

tip

Smaller is not always better. For me, xDs are so small that they are inconvenient because they can get lost in a pocket or in the recesses of a camera bag. I think CF cards are just the right size to carry, store, and save my precious images. Compact Flash memory cards also are very durable. For all these reasons, I prefer to use them.

Since we are talking digital technology and instant gratification, get the fastest card you can. Trust me, you will be happy you did! The card's speed directly influences the performance of your digital camera and the time it takes to download images to your computer. It is a simple fact that the superior performance of high-speed cards far outweighs minimal differences in price.

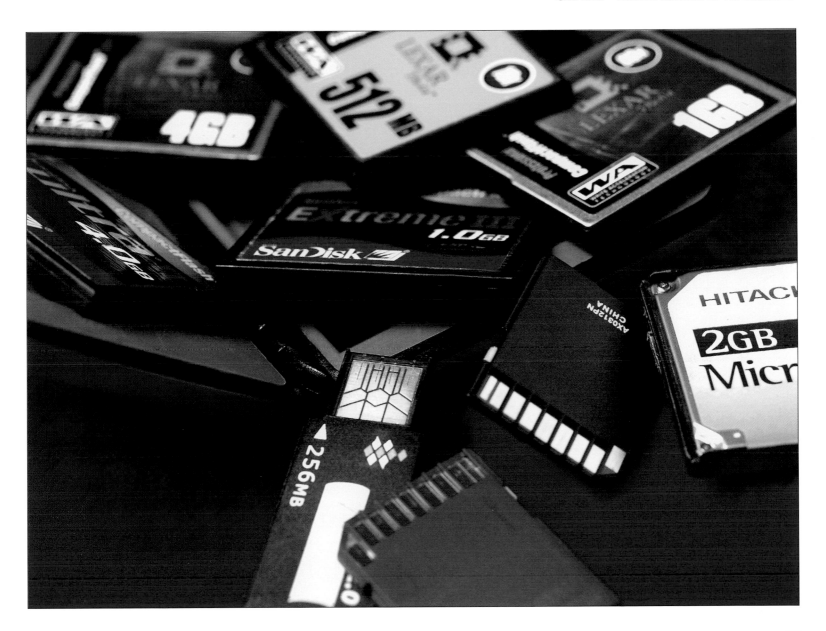

tip

Make sure you have a good storage case for the media. Always put them in a plastic cover when they are not in the camera to protect them from dust and moisture. If you use storage media with exposed contacts, be careful not to touch them. The oils on your hands can be transferred to the contacts and corrupt the information on the cards.

No matter what storage format you use, once you have purchased the media that you are shooting on, there is no additional cost. You can shoot freely without concern about spending money on wasted film or prints. After downloading the images to your computer, you simply erase the card and start over again. You can also make an unlimited number of backup copies of the images without any loss of detail or quality on hard drives, CDs, DVDs, tape, or other media. In contrast, copying film negatives results in increased contrast and grain, and loss of detail and resolution.

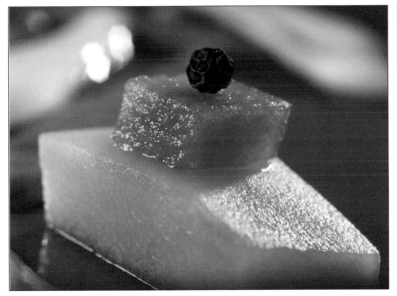

tip

When placing your memory card in your camera, pay attention to the direction the card goes into the camera. Never force the card in—be gentle! Also, make sure the camera is turned off before you remove the card.

There are two ways to transfer photos to your computer: by connecting a cable directly from your camera to your computer, or by inserting your memory card into a *card reader* that is installed in your computer or connected by a cable. There are many types of card readers available. The advantage of having a card reader is that you can keep shooting while the previous images are being downloaded to your computer. IEEE1394/FireWire readers are faster than USB 2.0 readers (one and a half times faster, according to my own experiments). If you have a laptop computer with a PC card slot (PCMCIA), you can use a PC card adapter to import your photos from your memory card.

tip

When I download images to my computer's hard drive, I label the file folder with the date in Year-Month-Day format so that all my files stay in chronological order. For example, September 16, 2005 would be 050916.

tip

Many problems are caused by trying to edit CF or xD in the computer. I prefer to erase and format storage media cards in the camera rather than use the computer to do so. Engineers have told me that this method does a better job of formatting the card to be compatible with the camera's software. This also helps you avoid damaging your cards.

Many digital cameras have the capability to photograph in a "burst" mode, which enables you to take a series of photos very quickly. The camera will pause for a few moments after a burst to process the series of photographs. The number of photos you can take in this fast-shooting mode varies depending on the camera. If you need to take photos very quickly—for example, to capture someone tossing pizza dough—you need a large image buffer. You can also increase the speed of shooting by using a larger, faster storage media card designed for professional cameras.

Photo Quality Settings

Most digital cameras allow you to take pictures at different settings. Each setting determines the picture's pixel count and compression rate. When you choose a particular setting, you are making a tradeoff between photo quality, how many photos you can store in your memory card, and the speed at which you can shoot. Here are the most typical settings:

❖ **RAW: High Resolution or Uncompressed.** Most professional cameras allow you to save images you shoot in RAW format, which simply means that none of the digital image is compressed or altered by the camera's software. The only camera setting you have to select is the ISO speed. RAW is the most editable and versatile digital capture format, and it is the recommended shooting mode for professionals. The RAW file becomes your digital negative. If you want the best possible quality, shoot in RAW. When I shoot in RAW format, images are typically 13.5MB.

❖ **TIFF: High Resolution.** TIFF is an acronym for Tagged Image File Format, one of the most widely supported file formats for storing photographs without compression. The image's white balance, sharpness, and contrast are processed by the camera's software. Compared to RAW and JPEG images, TIFF files are much larger and take longer to shoot and download because they are processed and uncompressed. When I shoot in TIFF, images are typically 23.3MB.

❖ **JPEG Fine: Super High Quality (SHQ).** At the JPEG (Joint Photographic Electronic Group) Fine setting, pictures are compressed as high-quality JPEG files. This enables you to store more pictures in your memory card without losing quality. This setting is ideal when you need to shoot in JPEG. When I shoot with my 8-megapixel EVOLT E-300, the typical file size is 6.1MB.

❖ **JPEG Medium: High Quality (HQ).** At the JPEG Medium setting, pictures are compressed more than they are at the Fine setting, enabling you to store more pictures in your memory card without losing too much information. That said, JPEG Medium quality is generally not sufficient for professional work, especially for capturing fine details in food. With my camera, the typical file size of a photo shot with this setting is 2–4MB.

❖ **JPEG Low: Standard Quality (SQ).** At the Low setting, pictures are very compressed. This setting enables you to store the maximum number of photos in your memory card. Although the quality is not sufficient for print, it may be sufficient for photos you plan to include on a Web site or send via e-mail. The actual quality of this setting will vary depending on the size of your camera's sensor. With my EVOLT E-300, file sizes of photos shot with this setting range from 100 kilobytes (KB) to 4MB.

tip

I prefer to shoot at either the RAW or JPEG Fine settings. Although RAW yields a digital negative that is completely unaltered by the camera's software, it can be faster and more convenient to shoot in JPEG Fine. This is especially true if you need to complete post-production quickly, because the images are compressed and processed in the camera. This saves time in post-production because you do not have to manipulate the color temperature, sharpness, contrast, saturation, and white balance as much as you would in RAW mode to get a printable image.

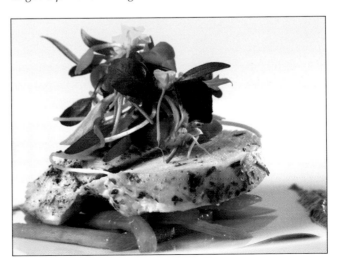

White Balance

White balance has long been a challenge for professional photographers. For example, have you ever taken photos with a film camera, only to find that when the prints came back from the developer, they looked green? Odds are, this was because you were shooting under fluorescent lights. Some lights are very blue (cool) in nature, while other lights are very yellow (warm) in nature.

Fortunately, digital cameras can automatically balance color in different lighting environments. This built-in automatic white-balance feature, which is enabled by default, reads the color of the light. Automatic white balance works well in most lighting environments. Digital cameras also have manual controls to change the white-balance settings or to create a custom white balance (see your camera's manual). Use the manual feature when your pictures have a color cast to them, or if you want to create a special color effect.

tip

I always set the white balance to manual mode. Often, I create a custom white balance to get better color rendition. Also, when you're using electronic flash, the white balance must sometimes be set manually because the light doesn't exist until the flash goes off. A setting for daylight is usually correct.

Flash Settings

Although I do not recommend using built-in flash, most cameras default to having this feature turned on when there is not enough available light. Cameras have this feature because when photographers are just starting out, it can be hard to determine which environments need more light and which ones do not.

Some cameras can be set to fire the flash all the time, which is useful when you want to balance light that is too bright. This is called *fill flash*. For example, if you were taking a photo of a picnic scene in bright sunlight, you could use the fill flash to increase the detail in shadows caused by the sun.

Although built-in flash does have its uses, external flash is the preferred light source for professional food photography. External flashes are better because you can control the direction of the light and bounce the light onto different surfaces for a softer, more diffused look. (We'll talk more about lighting in Chapter 7.) I use professional lighting equipment such as studio strobes, soft boxes, umbrellas, and grid spots.

tip

One thing to watch out for is the sync cord voltage of your studio strobe equipment. If the voltage is too high and the flash is connected directly to the camera, the voltage can fry the camera's delicate electronics. A simple solution is to use a device in the sync cord line that reduces the voltage, generally to 6 volts.

Focus

Today, auto-focus technology is highly advanced. When you take a photo with a digital SLR camera, you can see the image come into focus when you look through the viewfinder. There are different types of auto focusing available; in addition, most digital cameras with auto focus allow you to manually override this feature. Following are the most common types of auto focus:

❖ **General auto focus.** General auto focus mode is ideal when you are at least a foot away from the subject. This setting automatically focuses on the center point in your viewfinder. Some digital cameras show you the center point in the viewfinder when you press the shutter button halfway; other cameras allow you to pick different spots to focus on.

❖ **Macro auto focus.** Macro auto focus is for shooting objects very close up. Normally, if you focus on an object very close to the camera, it will be out of focus if the camera is moved even slightly. This auto focus setting keeps the object very sharp, even at close distances.

❖ **Manual focus.** Manual focus is used when you need to focus on a specific area of the photo. All professional digital cameras have this feature. Check your camera's instruction manual for the specifics on setting your camera to manual focus. On most digital cameras, you control manual focus by turning the focusing ring on the lens of your camera to the left or to the right.

note

One advantage of manual focus is that there is less lag time between pressing the shutter and the camera taking the picture. With manual focus, the electronics of the camera are not trying to find a spot on which to focus automatically. My Olympus camera allows me to auto-focus and then fine-tune by overriding the automatic setting with manual focus. This enables me to pick a precise, specific point in my photograph, and work more quickly and smoothly.

Using a Tripod

It is best to use a tripod whenever possible to ensure a clear photo. Purchase a tripod that is lightweight and compact, so it will be easy to carry. Most tripods attach directly to the base of the digital camera. Some have a quick-release feature, which I strongly recommend. This will allow you to move the camera off the tripod—for example, to shoot at a different angle—without disturbing your setup. If you do not have a tripod, it is important to hold your camera tight and close to your body. I typically brace my elbows against my ribs to keep the camera steady. Alternatively, try resting or bracing your camera on any steady surface that happens to be available.

As you can see, digital photography technology has come a long way, and it continues to advance quickly. We'll continue to see better resolution and higher megapixels. The early "professional" digital cameras yielded 1 or 2 megapixels and cost thousands of dollars. Now it is common to see point-and-shoot cameras with 5 megapixels.

Depending on your needs and budget, you can take advantage of a wide range of automatic and manual features to achieve very good results. As you become more proficient, you will be able to push the envelope, using digital technology to fully realize your artistic vision.

CHAPTER 3

Who's Digesting It: Advertising,
Packaging, Public Relations,
and the Media

Image is everything in food photography. We are a generation of visual people, and we are naturally stimulated by what we see. Beautiful food images conjure up all the human senses. We can be comforted by nostalgic images that recall our past, and can be stimulated by pictures that present food in exciting, new, and colorful ways. In other words, we respond to images that have appetite appeal and look fresh. Enthusiasm, fun, and spontaneity are contagious, and I try to convey all of this in my photographs.

Among the goals I have for readers of this book is to help them understand various techniques to create successful food photographs—and, of course, to attract clients who are willing to pay for them. Naturally, media and marketing professionals understand that food is a pleasure as well as an essential part of life. They use imagery to communicate that message—drawing us in, and keeping our senses at full attention.

tip

Throwing certain objects out of focus, tilting the frame, soft lighting, and tight close-ups are some of the techniques I use to get the viewer's attention and achieve desired effects. Most of the time, simplicity rules; less is more when it comes to food photography.

Because food is perceived differently among diverse audiences, photographers need to vary their approaches and styles depending on how their pictures will be used and who will be looking at them. Advertising images are designed to communicate feelings and messages that are different from those in news stories and magazine articles. For example, a photograph that was taken for use on a billboard won't necessarily be appropriate for a newspaper recipe section, fitness magazine, or industry trade publication. In addition to factors such as composition and prop styling, there are technical aspects, such as lighting, contrast range, and file size, that need to be considered for different types of usage.

This might mean producing several variations of a picture—for example, a "beauty shot" for glossy ads, a version showing explicit brand identification that can be used in trade publications and product catalogs, and another version, in which the brand name or label is only partially visible, that can be distributed to newspapers and consumer magazines.

Because short deadlines and quick turnarounds are common for food photographers, speed and accuracy in a shoot significantly affect the client's profit margins. That's why you need to go into each shoot with a firm sense of who will be "digesting" your pictures. You need to know *before* you begin what your pictures are going to be used for—advertising, the media, public relations, or packaging —to most effectively plan and execute the shoot.

Fortunately, digital photography simplifies the creative process without compromising quality, and it increases your ability to more quickly produce a better picture that's ready to be used commercially.

Questions, Questions, Questions

Whenever I begin a new project with a client, I consider the following questions, and I urge you to do the same. Knowing the answers before you begin makes your job easier so that key elements of the shoot—such as styles, props, lighting, and contrast range—can all be planned in advance.

What Is the Purpose of the Photograph?

Without a doubt, this is the most important question you can ask your client. The answer will determine your entire approach to the shoot and post-production process. Knowing the purpose of the picture will naturally lead you to considerations in planning and executing the shoot, such as the following:

❖ Will a food stylist be needed?

❖ What props should be used?

❖ Will people be in the picture?

❖ Can a product label be shown?

❖ Do you have to leave room for type on the page?

How Will the Type of Media Usage Affect Technical Aspects of the Shoot?

If the picture will appear in a glossy magazine, poster, or billboard, it is a virtual given that the final image will be high-resolution full color. On the other hand, if the picture is intended for use on a Web site, the final image will need to be at a much lower resolution so it downloads quickly, but should still look bright, clear, and sharp on a wide range of monitors. If the image is going to be used in a newspaper, lower contrast will be called for, and the picture may have to be provided in both color and black and white to meet the needs of various publications.

How Large Will the Image Be When It Is Reproduced?

The physical size of the final image will also dictate the amount of subject matter and detail you will include. If the reproduction will be very small or on low-quality paper, you might include only the main subject with few props and little or no background detail. On the other hand, if the picture will be used as a two-page color spread in a glossy food or travel magazine, you would very likely compose the subject with a more complex background, carefully styled, and with a full array of props.

What Is the Budget for the Shoot?

Budgets are the highest in advertising photography, because they require the most preparation, staff, and resources. (Typically, the photographer, food stylist, and prop stylist all have assistants.) The best of everything —food, props, backgrounds, and state-of-the-art photo equipment—is purchased or rented to ensure that the highest-quality photograph is obtained. Because they are often placed in major media, advertising photos typically have the highest value and cost. Packaging budgets are also high, and require similar resources as advertising photographs because the same high-quality final product is required.

Photographs for public relations and media usage have lower budgets, although some of this photography does allow enough for limited prop and styling resources or staff support. The pictures tend to be simpler, more casual in appearance, and have a shorter "shelf life" in that they are often taken for one-time or limited usage. Clients are not willing to spend as much for these photos because they have less value than advertising or packaging photographs.

The Digital Reality Check

Advertising, media, and public relations clients have a lot invested in their products, both financially and emotionally. As a result, they can be very literal in their demands for the final image. For example, clients often want to include too much in a photo, or sometimes don't understand the needs and realities of different media usage.

Many times in my career I have heard from clients:

> *"But that's not how you set a table!"*
> *"I don't like the tilted plate. The food looks like it's going to slide off!"*
> *"That corner of the photo looks too empty."*

Battling that literal nature is the photographer's plight. Saying "I'll do whatever you like!" is often the best way to begin your relationship with your client. Diplomacy, patience, humor, and depth of understanding go far in determining the best way to convey an image.

As a digital photographer, I have been able to reduce the amount of negotiating I have to do with clients in order to give them the pictures that best suit their needs. Digital photography enables me to show clients what they *think* they want to see, and then show them what works better visually. It's absolutely true that a picture is worth a thousand words—*everyone* reacts to visuals! The picture is most often the hook that draws attention to an ad, article, or product package.

Shooting for Advertising, Packaging, Media Usage, and Public Relations

Important differences in the purposes and needs of advertising, packaging, media usage, and public relations dictate the approach you will take in your digital food photography.

Advertising

When taking photos that will be used in advertising, you aim for perfection in every aspect of the shot. Advertising pictures are designed to depict the product in an ideal state to entice people to buy a product. These pictures can be placed in a wide range of media, such as magazines, newspapers, TV, posters, and the Internet. These images also can be found in many other kinds of media, such as product brochures, restaurant menu boards, and retail point of purchase displays.

Food manufacturers invest a great deal of money to generate customer loyalty and establish an emotional bond with the consumer. There is far less creative freedom in advertising photography than in shooting for media or public relations. Advertising photographs, as well as photos used for product packaging, must explicitly reflect the art director's vision and layout, without deviation.

Art directors create the concept of the shoot, after which a photographer is selected and the creative process begins. Food and prop stylists create the perfect look that will grab the audience's attention. In especially large or high budget projects, the stylists might in turn hire additional staff members.

Advertising involves far more intense attention to every aspect of the food, props, and lighting than any other area of food photography, and is by far the most labor and time intensive. The art director and client are almost always present, and provide nearly continuous input and feedback during the shoot. The food stylist and prop stylist constantly adjust and fine tune the food and set to ensure perfection in every detail.

note

Although advertisements must always show the real food, it can be tweaked and accentuated in appearance.

Following are some specific examples of photographs used in advertising media.

Magazine Ads

Discover a New Way to
EAT
EUROPEAN AUTHENTIC TASTES

Experience the Seductive Flavors of Europe

Teach your customers to celebrate the pleasures of the table by discovering the regional specialties of Europe's fertile and diverse farmlands. From paper-thin air-cured meat from Italy and grassy single-pressed extra virgin olive oil from France to creamy goat's milk cheese from Greece and sultry ales from Belgium, delicious foods from Europe have long charmed and intrigued the American palate. With an appreciation for local ingredients and a respect for the traditional methods handed down for generations, consumers of fine food can enjoy the stories behind these products, but even more, respond to the flavors and sense of place in each bite.

Finding these products in the U.S. has become easier. The European Union (EU) has created a protection system that gives traditional, regional items from the EU a guaranteed stamp of approval. 'Designation of Quality' labels guard the names of foods that are made in defined geographical areas or specific production methods. These labels are the EU's way of offering consumers the best-tasting products Europe has to offer.

Table Tents

Photo Lou Manna

Frozen Sippers 7.95

Strawberry Daiquiri
Rum, Blended Strawberries, Lemon and Lime Juices

Piña Colada Rum, Pineapple Juice, Coconut Cream

Margarita Tequila, Triple Sec, Florida Lime Juice,

All available without alcohol 5.95

Summer Sippers 7.95

New York Sunset
Stoli Ohranj, Florida Orange Juice, Campari

Malibu Cocktail Malibu Rum, Banana Liqueur,
Pineapple Juice, Florida Orange Juice, Grenadine

Photo Lou Manna

Festival Martini

Our specialty!
Served chilled and straight up with gourmet stuffed
olives! Single serving 7.50

Double shaker 9.95
Add 1.00 for super premium labels

Classic Cocktails

Summertini Stoli Peach Vodka and Lillet,
a refreshing twist on the traditional martini cocktail 7.50

Cosmopolitan Absolut Citron Vodka, Cointreau,
Florida Lime Juice, splash of Cranberry Juice 7.50

Margarita Suprema Jose Cuervo Tequila,
Cointreau, Florida Lime Juice
With or without a salted rim. 7.95

Restaurant Menu Boards

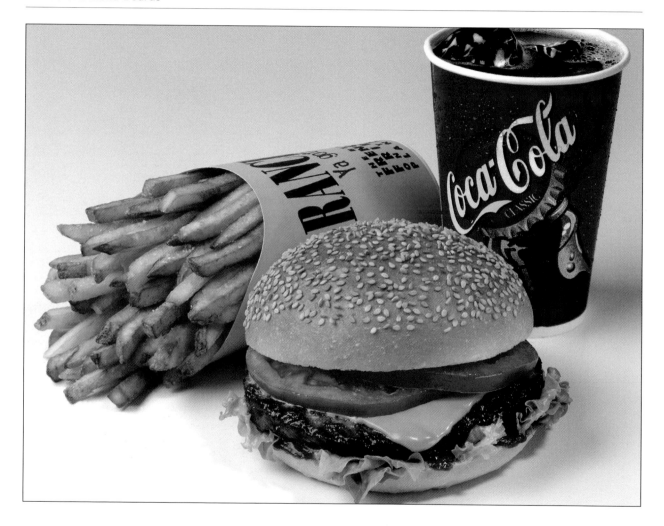

Brochures

Web Sites

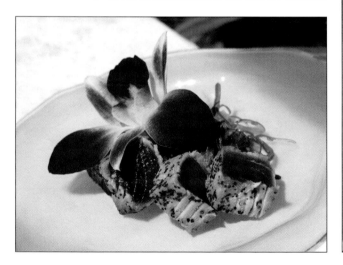

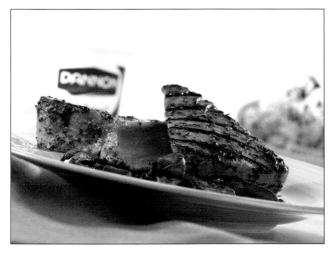

Product Packaging

Packaging is designed to convey the "personality" of the brand, and food product packaging is an art form unto itself. The package is what you face at the point of purchase. It is the hard sell. The image and brand awareness have to shine brightly. Imagery, color, logos, words, and graphics all work together to create a selling package.

note

Photos on food packages have been steadily increasing in size to increase the "saliva factor" and grab the consumer's attention.

Taking photographs for packaging requires strict adherence to a very precise layout, because space needs to be reserved for type and other graphics. When shooting for packaging, the contrast range is lower than normal in order to ensure that proper detail is maintained when the image is reproduced on a variety of surfaces, such as plastic, paper, or cardboard.

Generally, the package photo is a close-up view of the product, and is in sharp focus. Props are kept to a bare minimum so attention is on the product itself, but sometimes a little garnish—such as a sprig of parsley or fresh herbs—will be added to give the product more appetite appeal. In addition, the food stylist always works from the actual product to bring out the best of what the consumer will find in the package. Often, the stylist will open many packages to find the best examples of the product, and then will carefully enhance and arrange the various elements so the food looks its best.

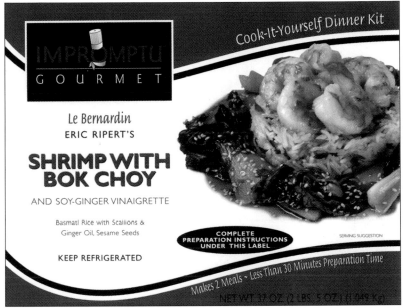

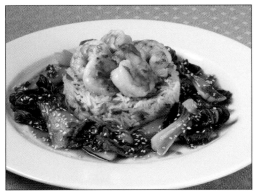

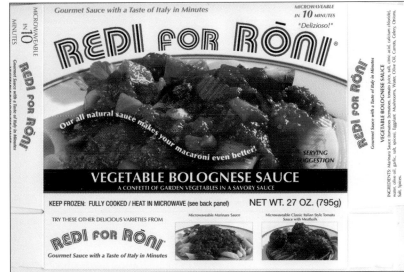

Media Usage

Photos for glossy magazines or newspaper food sections are likely to have the appearance of "casual reality." Editorial content is used in conjunction with recipes and pictures to draw the audience into the experience of food. These photos generally portray food in a way that tries to make the reader feel, "That's something I'd like to try," or "I can make that." There is a comfort level and approachability factor in the image.

Media usage is the area in which the photographer and stylists have the most creativity and freedom. Most of the time, there is minimal artistic direction from the client or art directors. The lighting contrast can be more pronounced, and there can be exaggerated shadows and more highlights on the food. In addition, soft-focus techniques and props can be used more liberally to create a mood. Because the photos often try to portray a sense of reality, we don't hesitate to allow imperfections in the food to show. The following are some examples of my food photography used in magazines and newspapers.

Magazines

Food Photography is a universal language.

Newspapers

No cooking, no kidding

See why raw cuisine is the latest trend in dining out

purists for over three years could be the radiant poster-children of this emerging lifestyle. Raw foodists have a "look" — no doubt about it. It's not that they are all so slim, but it's that luminous glow that makes them distinct. According to Bryan Marn, a manager at Pure Food and Wine and raw food devotee (who also has "the look") fruits and vegetables that are not cooked retain not merely vitamins but living enzymes and compounds that literally transfer to our bodies, making us more alive or vibrant (thus you get "the look").

No matter. This food is great.

Chef Matthew Kenny and his partner, Sarma Melngailis, at Pure Food and Wine, located at 54 Irving Place.

BY MARY MCGUIRE-WIEN
Special to amNewYork

As I stepped into Pure Food and Wine, I had a flashback of when sushi was just weird and wonderful, and not the obligatory neighborhood offering it is today.

Like early sushi bars, the room was comfortable, elegant and sexy wrapped in a shade of red that makes everyone look good. Also like early sushi bars, my mind was telling me that this sort of food just shouldn't work, as I puzzled over delicious yet mysterious mouthfuls of food. "Beet Ravioli with Yellow Pepper Puree and Cashew Cheese Filling with Tarragon and Pistachio Sauce?" And everything here is raw? How do they do it? And why?

It isn't hard to imagine raw cuisine becoming as ubiquitous tomorrow as sushi is today. Matthew Kenny and his partner, Sarma Melngailis, who have been raw food

PURE FOOD AND WINE

54 Irving Place
(212) 477-1010
To learn more about raw food living, go to
www.aiokhealth.com

The raw Beet Ravioli with Yellow Pepper Puree is a palette of bright colors and fresh tastes.

RECIPE

FROM PURE FOOD AND WINE'S KITCHEN

PINEAPPLE CUCUMBER GAZPACHO

Recipe Serves 4-6

Ingredients:
4 cups chopped pineapple
4 cups chopped, peeled cucumber
3 tbsp minced jalapeno
3 tbsp thinly sliced green onion
1 tbsp lime juice
1 cup fresh pineapple juice

2 tsp sea salt
½ cup loosely packed cilantro leaves
¼ cup finely chopped macadamia nuts
3 tbsp avocado oil, or cold pressed extra virgin olive oil

Add to a blender three cups each of the pineapple and cucumber, two tablespoons of jalapeno, two tablespoons green onion, lime juice, pineapple juice and salt and blend at high speed until smooth. Taste for seasoning. Because the sweetness of pineapples varies, the amount

of jalapeno and salt may need to be increased accordingly.

Add the remaining pineapple, cucumber and the cilantro leaves and 1½ tablespoons of the avocado or olive oil. Pulse the blender quickly a few times — the gazpacho should remain chunky. Add the macadamia nuts and stir to distribute them evenly.

Divide among serving bowls and drizzle with the remaining avocado or olive oil and sprinkle with remaining minced jalapeno and sliced green onion.

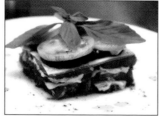

Industry Publications

In contrast, photos that are intended for use in industry publications might be simple, straightforward shots that can be used to introduce a new or improved product, packaging, or design to people in the trade. In these cases, your pictures are likely to have little or no embellishment, and prominently feature a bag, box, or label. Usually, prop stylists are not involved in these shoots because the product is shot against a plain or white background.

Public Relations

While food advertisers know that their pictures will be used exactly as they intend—because they buy and control the space in which their ads will run—in public relations there is little or no control over how pictures will be edited or used, if at all. In photographs for public relations use, where it is up to an editor to decide whether to use the picture in a news context, the product often needs to take a back seat to some other aspect of the picture.

When I take pictures for public relations clients, I keep the lighting simple and clean. I have a lot of freedom in arrangement and composition, keeping in mind that a natural, less staged looking picture usually has the best chance of being used by journalists and editors.

Sometimes, PR photos are distributed to the media as part of a new product launch—for example, a new line of Starbucks baked goods. Other times, the photos might be used to illustrate a general lifestyle message, such as Hellman's campaign to position its product as a viable, delicious ingredient for preparing foods.

Often, in addition to publicity shots, pictures that are taken for PR campaigns communicate something *newsworthy* about a product or an event to which it is connected. Event photos might include company executives, celebrities, or the public. Over the years, I have photographed numerous events such as the *Wine Enthusiast Magazine* Toast of the Town event, Taste of New York, the European Wine Council Gala, the Gingerbread on Broadway competition at the Marriott Marquis hotel, and the James Beard Awards.

When shooting at events, I use portable flash equipment on a bracket powered by an external battery pack. This gives me the freedom to move around unencumbered by wires and cables. Don't use a camera's built-in flash for this kind of work—it is not powerful enough to light the subject properly, it does not recycle quickly enough to take multiple shots in succession, and it can cause red eye, which needs to be retouched in post-production. You want to be able to turn these pictures around very quickly—the newsworthiness of the event is short and clients want to be able to have the final images right away.

tip

Placing the external flash on a bracket, or hand-holding it away from the camera, eliminates the chance of red eye and gives more depth to the photograph. I typically use a second flash that I trigger with a PocketWizardPlus radio transmitter. The second flash is on a tall stand with wheels off to the side, so I can move it easily.

Tabasco

One of my long-standing clients has been McIlhenny Company, makers of Tabasco Sauce. The following photos simultaneously evoke contemporary and traditional feelings. These photos, and hundreds of others I have shot for this company, have been featured in recipe cards, newspapers, and magazines across the country for more than a decade.

For one assignment, I produced photographs illustrating several recipes using Tabasco Sauce that were distributed to newspaper and magazine food editors. The pictures were also used by Family Features, a media company that widely distributes photographs and articles written by public relations agencies to local newspapers. Newspapers receive the material free of charge, and use it as filler between their own editorial content and paid advertisements. It is a win-win situation for everyone. Tabasco does not pay the price for an advertisement, and the paper receives a high-quality article that is ready for publication.

The PR photographer's challenge is to capture an image that can fit seamlessly into many media outlets' editorial and graphic styles without appearing to be promotional. In many cases, the product can be shown only subtly, and the label or brand might have to be hidden or kept in the background. While the long-term goal of a PR campaign is to create a "buzz" and make audiences feel good about a product or the company—and ultimately increase sales—the short-term strategy usually is to downplay overt commercial messages.

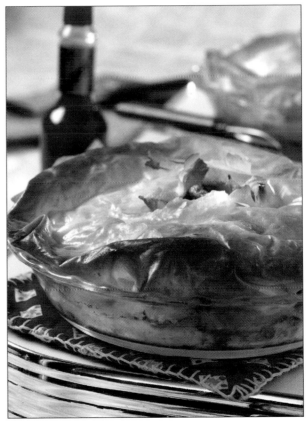

Barilla

Another wonderful working relationship has been with Barilla, the only national brand of pasta. Barilla's strategy is to remain loyal to the heritage and culture of Italy, while at the same time strengthen its image with a contemporary branding that communicates the product's superior quality.

Barilla has expanded traditional methods of marketing pasta through the use of public relations, advertising, and innovative packaging. The company has worked to develop a strong national brand identity through print media, an award-winning Web site, product information sheets, and sponsorship of large events such as the New York City Marathon. One of my photographs was used on a banner at the Barilla Marathon Eve Dinner at Tavern on the Green!

Advertising, packaging, media, and public relations are similar in that they all seek the consumer's attention. Whether you are flipping through the pages of a magazine or newspaper, passing by a billboard, or surfing the Web, compelling visuals are what attract your attention, whet your appetite, and pull you into the subject.

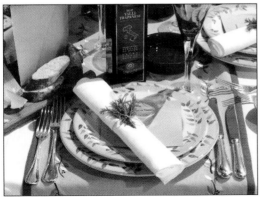

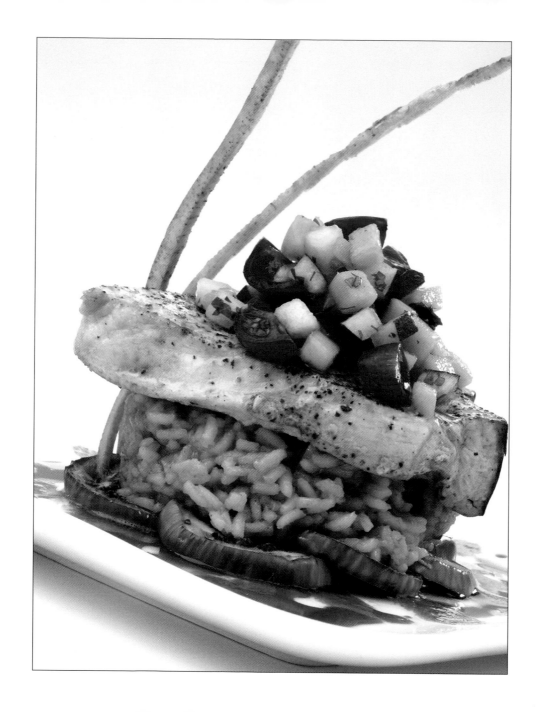

Teamwork is a key element of any successful food photo shoot. Depending on the size of the shoot, the team may consist of a photographer, an art director, a food stylist, a prop stylist, and production assistants. Team members collaborate during all stages of the shoot—planning, organization, execution, and delivery —in order to ensure that things go smoothly and that the result is a great product. The ultimate objective on any food shoot is to create images that appear fresh, artistic, and beautiful!

note

This chapter focuses on the role of the food stylist; you'll learn about prop stylists in the next chapter.

What Is a Food Stylist?

The food stylist's job is to create the food and dishes that appear in magazines, cookbooks, advertisements, food packaging, television commercials, and sometimes even feature films. Using behind-the-scenes magic and culinary artistry, a food stylist is responsible for making food look exciting, enticing, and effortlessly prepared—in essence, seducing the viewer. The food stylist brings to a photograph a creative eye, expertise in food preparation, and the artistic interpretation of the black-and-white words of a recipe. Having the food stylist involved in the planning, organization, and execution of a food shoot is a big advantage.

note

To find food stylists in your area, look to various organizations such as the Association of Stylists and Coordinators (http://www.stylistsasc.com). In addition, some food stylists have their own Web sites. You can search online and view their work to see if it meets your needs. Of course, word of mouth and referrals from other photographers, clients, and chefs are often the best sources of information. After you have identified a stylist, you should always meet personally to determine whether you will be comfortable working together. After all, it is a collaborative effort.

So what does it take to be a food stylist? Consider the following:

❖ Food stylists must have culinary training—indeed, some are professional chefs with culinary degrees—or a background in home economics.

❖ Food stylists must have knowledge of nutrition, cooking times, and techniques.

❖ Because photo shoots can run rather long, physical stamina is a must.

❖ Food stylists should have a good sense of humor. They should be open-minded. Patience, timing, and problem-solving skills are also imperative.

❖ Food stylists must be part magician, able to create "make-believe food" at times—depending on the type of shoot, real or simulated food may be used. Typically, taste is of little concern. Beautiful appearance is everything.

❖ Food stylists must be savvy shoppers and resourceful when it comes to finding unusual ingredients year round.

❖ Being able to envision the final photograph is an all-important skill of the food stylist.

❖ Food stylists must keep up with industry trends—or better yet, be able to create some of their own. In recent years, the trend has been toward more natural-looking photographs.

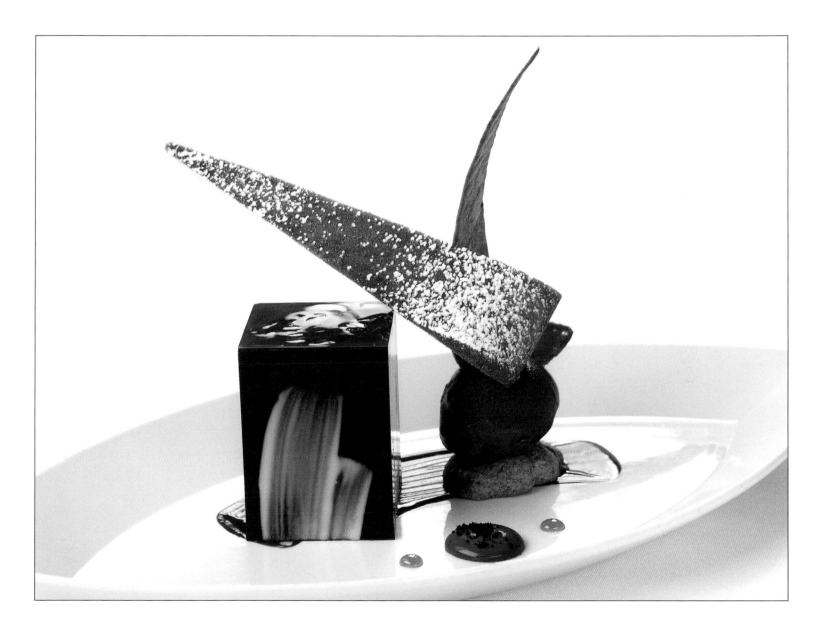

Pre-Production

As part of the pre-production process, the food stylist discusses the recipes, dishes, and visual concepts of the shoot with the client. The client may provide specific recipes, or the stylist may be asked to develop and test them. A strong nutritional background and menu-planning skills are advantageous at this stage of their work because food stylists are often called upon to pair and balance a wide variety of complementary foods and beverages in a single layout. After a client tasting, the recipes are given final approval, and they may even be quickly photographed for a visual record of what they look like.

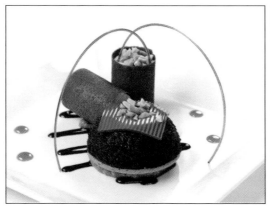

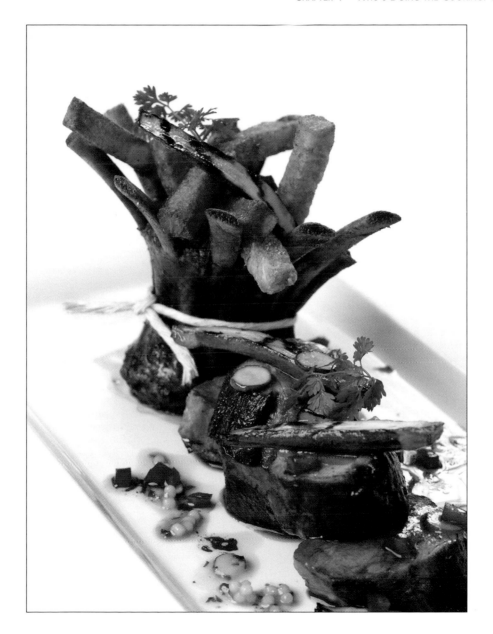

At the Shoot

Every good food stylist must be able to suggest and accommodate last-minute recipe changes and adjustments in order to make the dish look its best on camera. Moreover, food stylists are required to create beautiful dishes that can hold up for several hours on and off set, not to mention withstand hot, harsh lighting conditions. This ability is both an art and a science. Anyone who has worked on a food shoot can tell you that at the end of the day, some dishes do not always taste as good as they look!

As the photographer, you must make sure every visual element in the picture is complementary and in balance. I let the food stylist take charge of preparing and styling the food to its best appearance, but if I see something that doesn't work visually, then I don't hesitate to make suggestions. I always try to make the stylist aware of the angle from which I plan to shoot, and the type and direction of lighting I am using. Often, I request the stylist to prepare a "stand-in" or mock-up dish so that we can determine the best styling, composition, and lighting approaches. Factors such as the contrast in colors and textures of the food must be taken into consideration. Make it a point to evaluate all the possible presentations to determine what will create the most appetite appeal. Thanks to the immediacy of digital photography, the photographer, stylist, and client can look at the test shoots in real time and have input into what the final image will be.

Food-Styling Trends

As I discussed in the introduction, the look of food photography—angles from which the food is shot, lighting, and the styling of the food—have changed considerably. In the past, food stylists arranged elements on the plate specifically to be seen from above. There was hardly any height to the food, and there was sharp separation and distinction between the elements on the plate. This was consistent with the compartmentalized way food was arranged and served in the home, restaurants, and so on.

Today, especially in restaurants, food presentation is more integrated. There is more craft and intricacy in the details of dishes and their garnishes. For example, chefs have found that increasing the height and layering the elements of a dish is visually exciting, although many diners will tell you that it doesn't make the food any easier to eat! Accordingly, today's stylists must be more architecturally oriented, and able to separate food elements through contrasting textures and colors. It's a much harder job now than it was in the past, and the best food stylists are true artists.

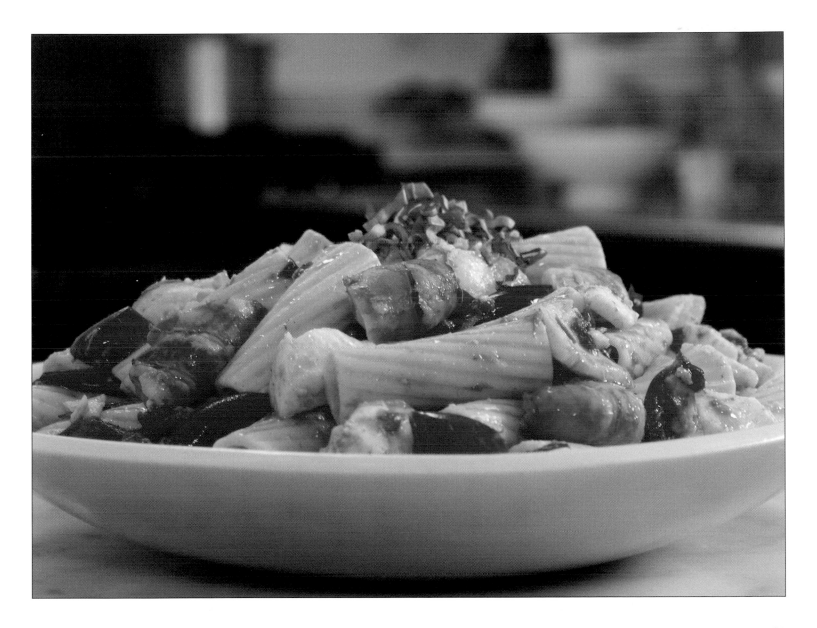

Food-Styling Techniques and Tricks

Food stylists use several techniques to make food look as appetizing as possible, as well as to counteract foods' natural process of discoloration, sagging, dripping, and so forth. For more information, read on!

Cereal

The secret to a perfect-looking bowl of cereal is a bottle of glue!

1. Select the best-looking flakes. Sometimes you have to go through several boxes of cereal to get a whole bowl's worth of perfect-looking flakes.

2. Fill the bottom of the bowl with white multi-purpose glue instead of real milk. The benefits of using glue instead of milk are easy to understand: The glue won't slosh around when the bowl is moved during the course of the shoot, nor will it become discolored after a long period under hot, bright lights. And of course, the carefully selected and positioned flakes will not move or get soggy!

3. Place a layer of flakes in the glue, and then add more glue around the edges of the flakes.

4. Use tweezers to individually position the flakes in the bowl.

5. Delicately spread more glue between the flakes.

Here's what the cereal looks like after it has been sitting in real milk for only a short time. It's what you're used to seeing every morning, but it's not suitable for a cereal box. So don't be afraid of filling a bowl with glue—you can wipe it clean!

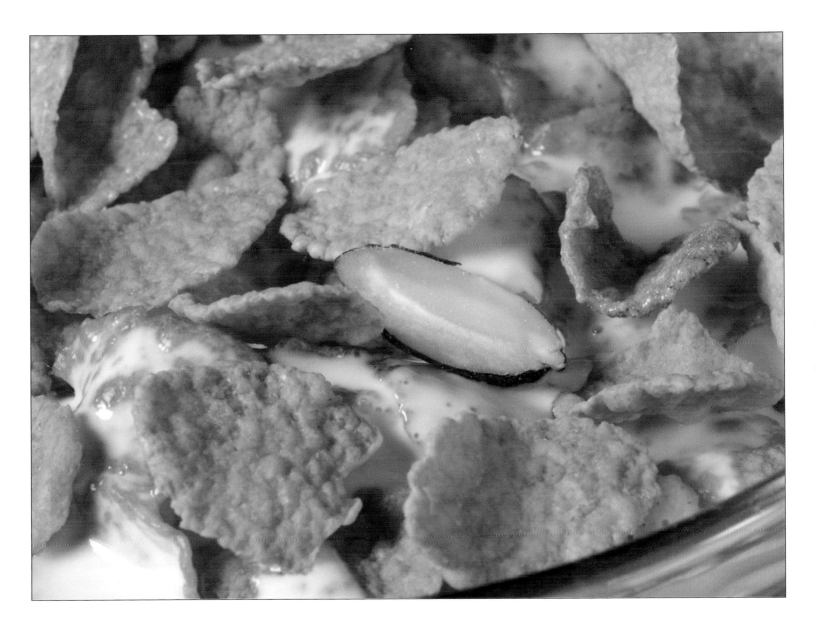

Often, when cereal is photographed, the image includes a spoonful. To style a spoonful of cereal, do the following:

1. Use a clamp to hold the spoon firmly in place. Place glue on the spoon and add flakes with tweezers.

2. Add more glue between the flakes with a toothpick. The direction you tilt the spoon will determine how the drip will flow.

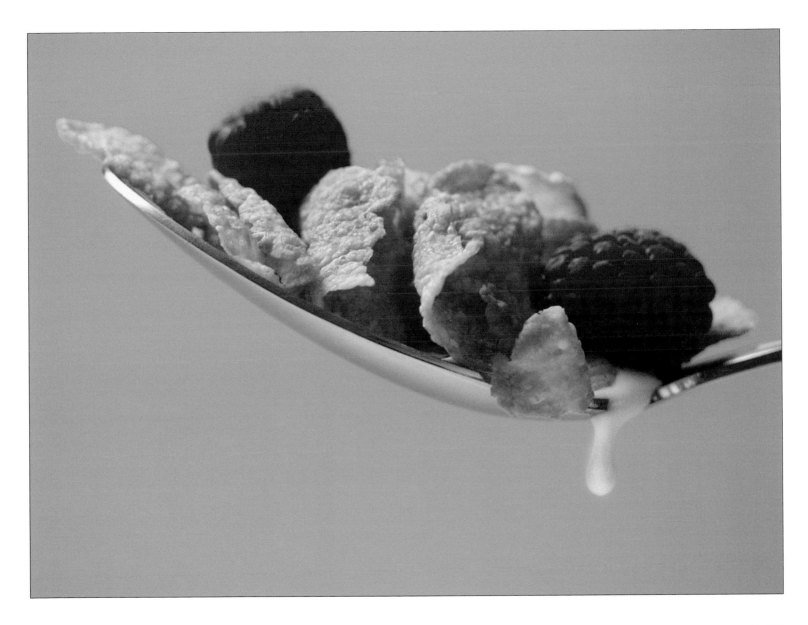

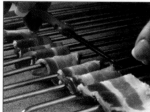

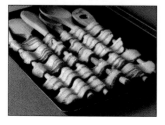

Bacon

Bacon is available at many supermarkets in disposable plastic packets that can be cooked in the oven or microwave. Some food stylists prefer to use this product. After cooking the bacon, a great way to keep the strips pliable is to place them in vegetable oil. Perfectly wavy bacon can be achieved by weaving it through the rungs of a wire rack, trimming the strips with scissors where necessary. A modern trick is to use wooden spoons or dowels to create a more natural appearance. To give bacon that "right-out-of-the-frying-pan" appearance, delicately place soapy water on the strips.

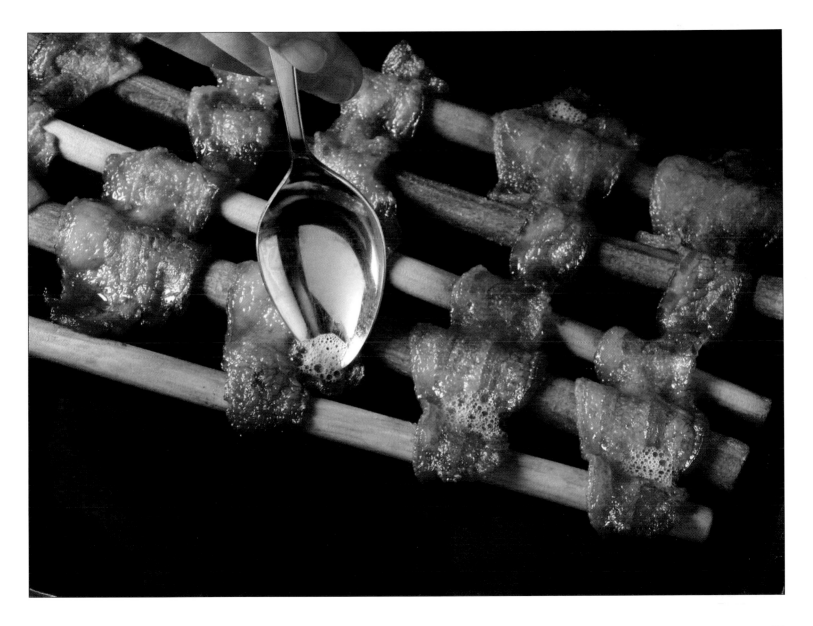

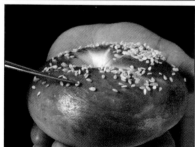

Seeded Rolls and Bagels

Sometimes bread, rolls, and bagels do not have enough seeds, and need to be enhanced. There are two primary ways to accomplish this. One method is to spread Vaseline over the area and sprinkle on the seeds. Although Vaseline gives the stylist flexibility in placing and moving seeds, it adds shine to the surface, so many stylists prefer the second method: dabbing an area with Krazy Glue and positioning the seeds individually to keep the original finish. With both methods, a good eye, a pair of tweezers, and a steady hand are essential for seed placement!

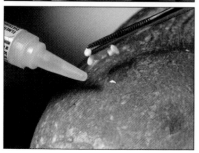

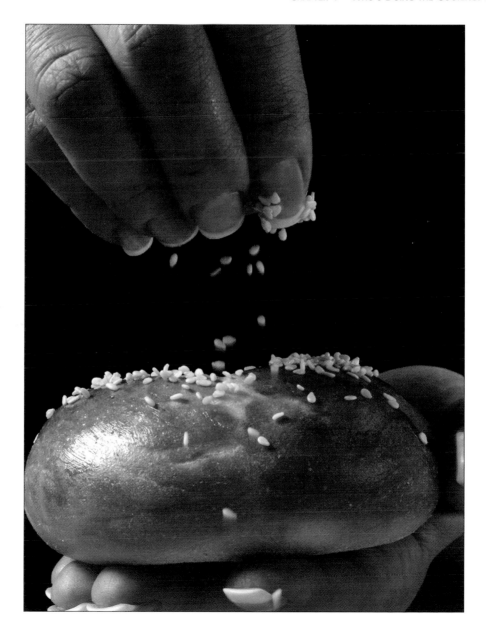

Pancakes with Butter and Syrup

Pancakes should be cooked at a very low heat, with little or no fat in the pan, to prevent over-browning. A non-stick pan coated with baking spray works best. Stylists use a combination of light and dark corn syrup or honey in lieu of maple syrup, which is too thin and runny. Years ago, motor oil was used. Kitchen Bouquet, a brown food coloring available in most supermarkets, can be added to achieve a darker appearance. The thicker syrup also gives better control over its placement. If the photograph requires a pat of butter, use margarine; the color is much better. Use a steamer to partially melt the margarine and create the impression that the pancakes are piping hot.

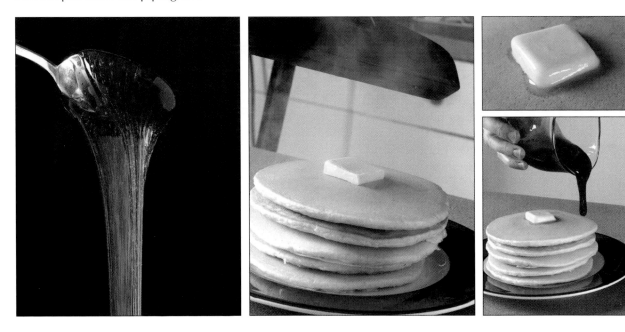

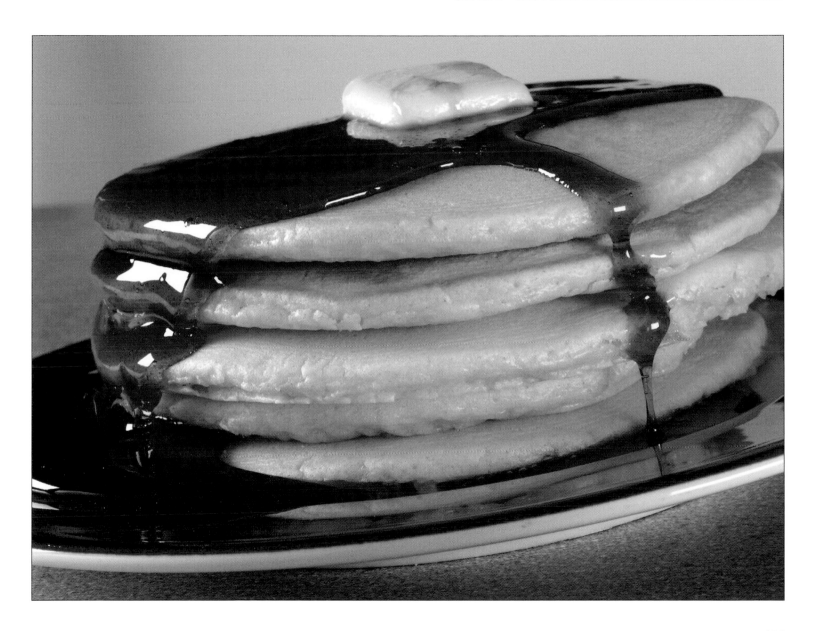

Grill Marks

To create the effect of grill marks on food, some stylists use metal skewers heated over an open flame, while others prefer to use an electric charcoal starter. The electric starter makes a wider mark and minimizes your chances of burning yourself.

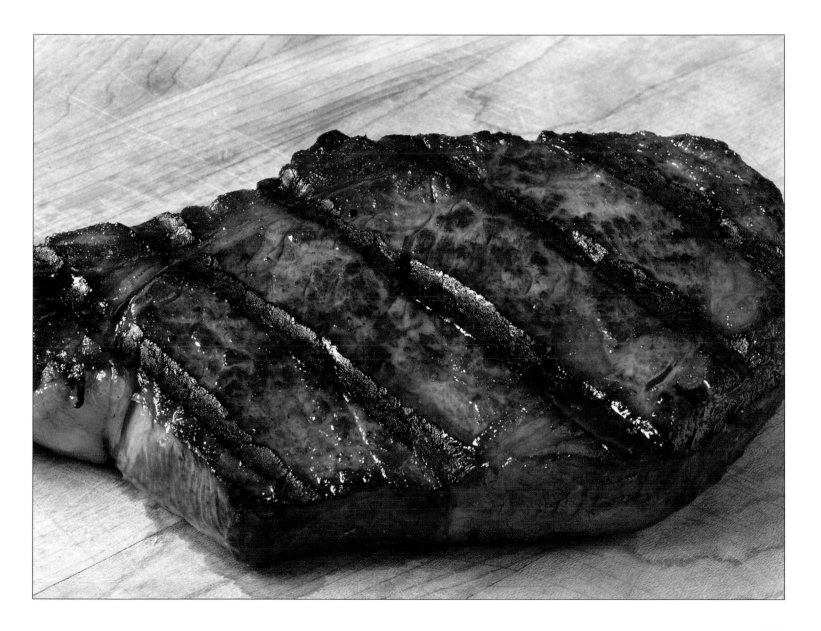

Chicken Legs

Preparing chicken legs can be tricky; be sure to make extras in order to get the perfect one. Before cooking them, use T-Pins to hold the skin to the backside of the leg. Do not cook the chicken thoroughly in the oven; doing so will cause the skin to shrink. After they've been cooked, brush Kitchen Bouquet or bitters, a common cocktail ingredient, over the legs to add brown coloring.

Fresh Herbs

Because most fresh herbs wilt quickly, it is important to make sure they look alive and healthy for the entire shoot. To revive or freshen the herbs, trim the stems and place the herbs in an ice bath. Dunking the leaves in ice water also helps. A spray bottle filled with water can be used to add droplets to the herbs to give the appearance of dew.

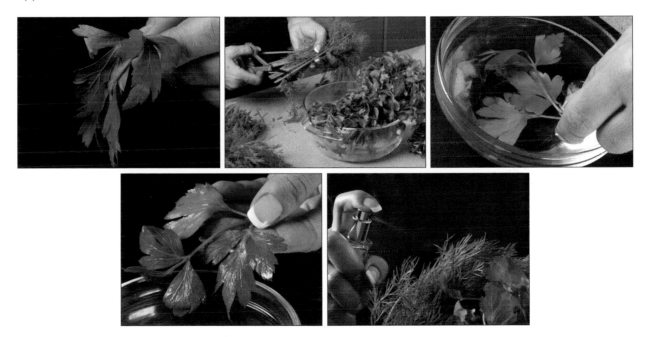

Pizza

Don't you love a hot, cheesy pizza, fresh from the oven? To style pizza for a shoot, do the following:

1. Pre-bake the pizza dough at 350° for approximately 8–10 minutes.

2. Cut a slice from the pre-baked dough, but leave it in place.

3. Slice small, thin pieces of whole-milk mozzarella (large pieces of cheese will run together and won't create the desired effect). Place the individual pieces of the cheese along the edge of the cut slice.

4. Sauce only the perimeter of the pie. The cheese will turn orange if sauce is spread over the entire pizza.

5. Sprinkle shredded mozzarella over the entire pie, placing slightly less cheese over the area where the slice has been pre-cut.

6. Brush olive oil on the crust to reduce the amount of bubbles from baking and to give the pie better color.

7. Bake the entire pie until the cheese is melted and the crust is lightly browned.

8. Cut a triangle of cardboard slightly smaller than the slice, and attach it to a thin spatula. You will use this to remove the slice from the pie.

9. Use a steamer to freshen the cheese or create a bubbling effect.

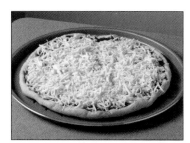

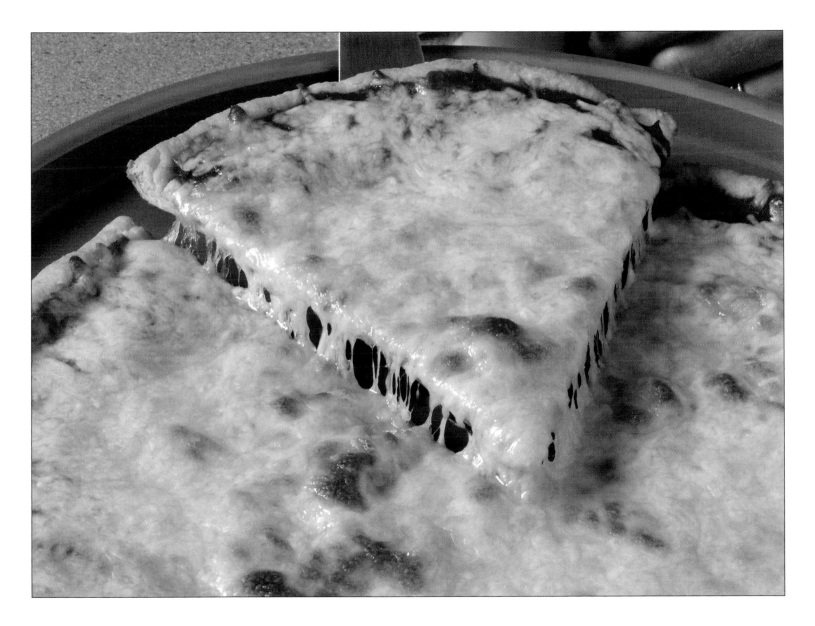

Beer

There's nothing that looks more thirst-quenching on a hot summer day than an ice-cold beer with a nice, foamy head. Here's how it's done:

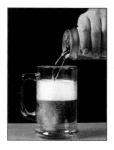 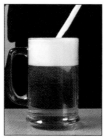 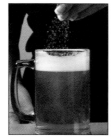

1. We actually use warm beer because it has more bubbles. To begin, pour the beer right into the middle of glass and stir it with paper-covered straw. Be sure to leave the wrapper on the straw while mixing because this helps stimulate the bubbles even more.

2. When the foam subsides, add a pinch of salt to the beer to revive the head. When mixing the salt into the beer, use the straw, with the paper still on it. The head will last only a short time, after which a little more beer will need to be added. You can perform this trick only a few times, and then you will need to pour a new beer.

3. To create the effect of condensation on the beer mug, use an equal mixture of glycerin and water in a spray bottle to add small droplets. For larger droplets, use Aquagel, a commercial product sold for this photographic purpose. It can be applied with a wooden toothpick.

Ice Cubes

Real ice cubes float to the top of the glass and appear cloudy in photographs. For this reason, food stylists use acrylic ice cubes, which are hand-carved and very expensive. These acrylic cubes show up clear and allow bubbles to appear in the glass, and can be purchased or rented at photographic supply houses. Acrylic ice cubes and many other fabulous fakes are also available online from vendors such as Trengove Studios in New York (http://www.trengovestudios.com).

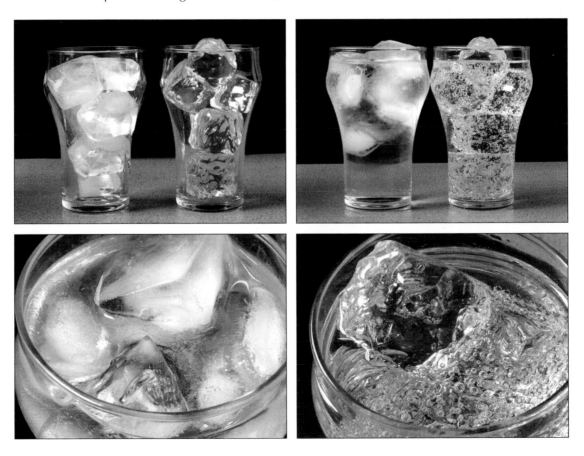

Ice Cream

Photographing ice cream is difficult, primarily because it melts quickly. For this reason, fake ice cream is used whenever possible. Some stylists use instant mashed potatoes, while others make their own mixture. Here's a recipe:

1 cup vegetable shortening

1 cup light corn syrup

3 pounds powdered sugar

Food coloring, as needed

Beat ingredients together in a stand mixer, and store at room temperature.

Here are a few tips for working with fake ice cream:

❖ Break the mixture apart using your hands to create texture.

❖ Use an ice cream dipper and your hands to form a perfect scoop.

❖ A "collar" can be added while scooping to make the ice cream look ruffled. Use a palette knife to accentuate the collar and to change the shape of the scoop. Using a palette knife is also helpful for filling in cracks.

❖ To create the appearance of fruit in the ice cream, strategically place tiny amounts of jam in the scoop.

❖ To make a sundae, drizzle chocolate sauce thickened with corn syrup on top of the scoop.

You would never use fake ice cream when shooting for an ice cream company. For a "generic" shot, however, the food stylist and photographer can use real or fake ice cream. Photographers always prefer to use fake ice cream because of its ease of use and longevity. If you must shoot real ice cream, make plenty of scoops in advance and keep them in the freezer until you are ready to use them. Use "stand-in" fake ice cream or some other object that is similar in color and shape for the test shots. Be sure to have a cooler filled with dry ice near the set to keep the ice cream cold and hard between shots.

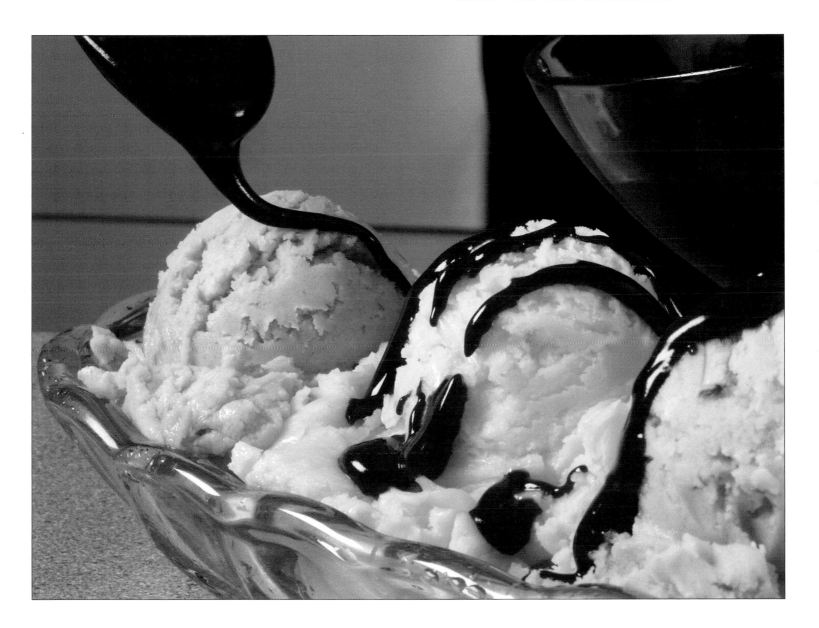

Chocolate Curls

Perfectly shaped chocolate curls are an attractive garnish to many desserts. Here's how to make them:

1. Add four to six ounces of butter, shortening, or margarine to a pound of chocolate chips. This adds fat to the chocolate, which makes it more pliable and malleable.

2. Melt the mixture in the microwave, stirring it well afterward until fully combined.

3. Pour the melted chocolate mixture into a small, greased, plastic container, and refrigerate or freeze it for one to two hours.

4. When the mixture is solid, remove the chocolate block from its container by patting it onto a cutting board.

5. Use a vegetable peeler to make perfect chocolate curls.

6. Keep the curls refrigerated until it's time to use them.

7. Using a wooden skewer, delicately place the chocolate curls on the dish.

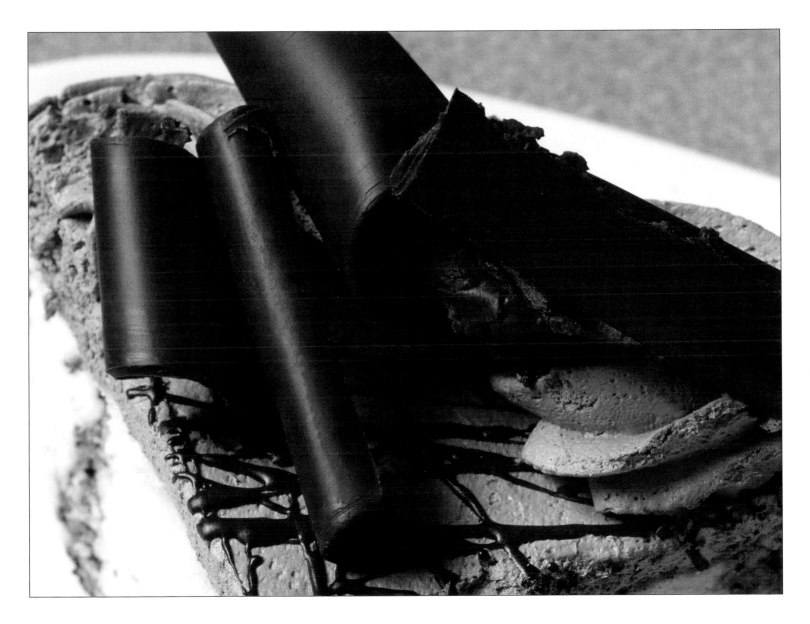

Pie

A great way to create the effect of a fruit-filled pie is to fill the crust with mashed potatoes and place the actual fruit on top. This enables you to use less fruit filling, and the potatoes prevent the crust from shrinking. To photograph a slice of pie, or pie with a slice removed, do the following:

 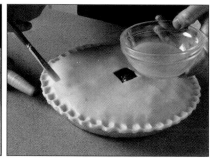

1. Before baking the pie, brush its rim with egg wash, which is simply an egg beaten with a little milk, to create a good seal between the top and the bottom. Crimp the edges with your fingers, and egg wash the top to ensure a nice, golden brown crust.

2. After the pie is baked, make sure it is very cold before slicing.

3. Use an Exacto blade to make the first cut, and then follow with a long, sharp knife.

4. Remove some of the potatoes from the visible side of the slice and refill that area with fruit.

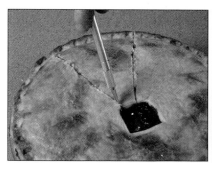 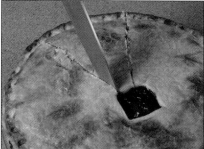 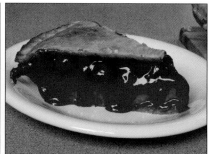

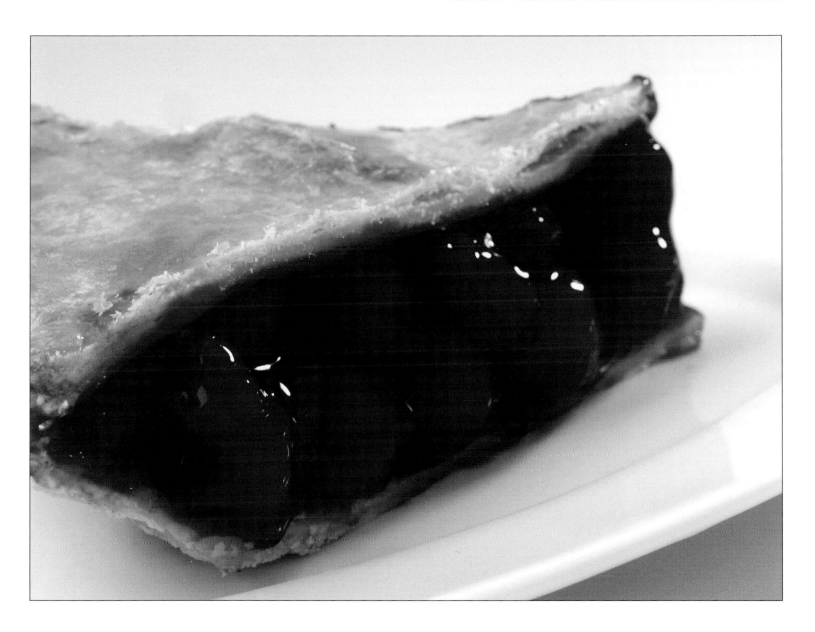

Dollops

If you're shooting slices of pie, or perhaps an ice cream sundae, your client may want you to add a dollop of topping. Cool Whip is best for creating dollops. Before you begin, be sure to thaw the Cool Whip completely. Then, with the edge of a tablespoon, make lines across the Cool Whip while it is still in the container. This will create a rippled look when the dollop is made. Use the spoon to scoop out some Cool Whip, and twist the spoon slightly as you apply it to create an interesting peak.

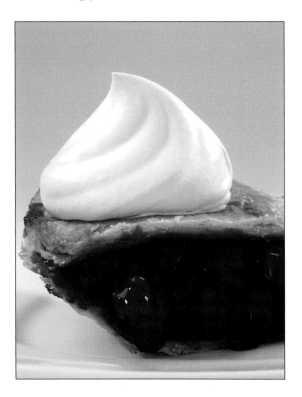

"Saucing Up" Your Dish

To create a more artistic look for your dish, you can use a tool as simple and commonplace as a plastic squeeze bottle or teaspoon to drizzle sauce. Either tool helps provide control over what is normally a difficult-to-manage ingredient. Think of the plate as a blank canvas, and use your artistic ability to create a design that perfectly complements the main dish. The artistry of a professional food stylist really shines here!

Additional Tips

Here are a few more food-styling tips:

❖ To maintain the hot, steaming look that a cup of coffee has when it is first poured, simply add soapy water to the cup.

❖ Always under cook food—especially meat and poultry—so it doesn't look dried-out and wrinkled.

❖ Apply vegetable oil or corn syrup to rice and pasta to prevent sticking and to provide a nice shine.

❖ Use lemon juice to keep cut fruits and vegetables from discoloring.

❖ Select vegetables individually and cook them separately.

❖ Use a brush when applying vegetable oil to add shine to cooked ingredients.

❖ To add height to food, use a can, pastry ring, or cookie cutter for support.

CHAPTER 5

Prop Styling: Who's Doing
the Shopping?

The prop stylist is integral to making a photo shoot successful. Put simply, while the photographer captures the story that the client wants to tell, the food and prop stylists are the artists who *create* the story. It is a team effort. In particular, the prop stylist determines the visual elements needed to get the shot. The prop stylist must be a savvy, smart shopper, must be well-organized, and must be resourceful and prudent in his or her use of time. Prop stylists must also be able to work within tight budget constraints. In addition, patience and flexibility are traits that go a long way.

note

It is critical that the prop stylist understands what the photographer and client want, and anticipates ways to help them achieve their creative vision.

The Creative Process

At the start of a project, the prop stylist acquires information from the photographer and client about the concept and vision for the shoot. This includes a shot list, which describes each photograph to be taken and the recipes that will be used. The prop stylist discusses with the photographer, food stylist, and client the overall design elements, background, surface materials, and accessories that will be required. Budgets are also established at this time.

After styles, designs, and colors have been determined, the prop stylist develops a production list and a prop list. The production list is, in fact, an annotated shot list that describes the creative specifications of each shot, including the following:

❖ Tabletop or room setting

❖ Themes and motifs (for example, traditional, modern, or ethnic)

❖ Colors and textures of tablecloths, napkins, and dishware

❖ Serving sizes for each recipe

❖ Condiments and beverages that might be included

note

The production list is a continuous work in progress, and is often adjusted and modified as the project proceeds.

The prop list is created from the production list. It lists the specific plate, glass, flatware, tablecloth, and accessories that will be used for each shot, as well as the exact background and surface materials. This is the prop stylist's "shopping list."

Basic Considerations

In almost every shoot, there are some basic considerations that the prop stylist must address:

❖ How many shots are there?

❖ Do the pictures have to match a style that is always used for a particular product, client, catalog, or magazine? If so, then the stylist will need to obtain as much information as possible from previous shoots. He or she should ask the client for tear sheets, or track down the previous photographer for information.

❖ What are the proportions of the shot—a partial or full dish, a meal, a table setting, or a complete room set? A meal shot might include lasagna with salad, garlic toast, and drinks for one person. This might be on a table with minimal props or simply the dish on a surface. A table setting would include plates or portions for more than one guest, and may also include serving dishes with full table dressing. A complete room set could show a table setting with dining furniture, wall units, and lighting.

❖ What is the budget? This should be firmly established. If not, the prop stylist will need to provide the client with a realistic estimate of how much the entire prop expenditure will be. Be sure to take into consideration the expense of having multiple choices for each prop, as well as delivery of props. Once you have a definitive estimate, discuss whether all the planned props can be obtained, or if items must be removed because of budget constraints.

tip

It's imperative that you get your client's night and weekend phone numbers. That way, when shopping for props at off hours, you can maintain contact with your clients. You never know when you'll find that perfect item that's just outside your budget!

Locating Props

Props may be available in the photographer's studio, or may come from the stylist's own collection. Depending on the budget and requirements of the shoot, the stylist may purchase new props such as napkins, dishware, and glasses, which can be used on the shoot and in other projects for that photographer or client. Other props, such as a large coffee urn that would not be used again, might be rented. The same is true for large surface and background materials, such as tabletops, chairs, wall units, and other decorative items. Many large cities boast prop houses that cater to professional photographers and stylists for just this purpose. Consignment and antique shops, as well as other local retail shops, are other good prop sources, even for rentals. Weekly rental fees typically run 20–30 percent of the item's retail price.

tip

Stylists should keep track of the props used with specific shots because it is sometimes possible to use the same prop in another shot, thereby saving time and money. For example, a platter on which food is featured in one shot might be used as a background prop in another.

129

At the Shoot

Prop stylists organize the delivery of props to and from the shoot, as well as build or oversee the construction of the set. At the shoot, the prop stylist prepares the set for each shot, assisting the photographer and food stylist in the placement and arrangement of all the visual elements. In addition, the prop stylist helps maintain an organized flow of the shoot. As you can imagine, good communication and camaraderie between the photographer, food stylist, and prop stylist is the best recipe for success!

After the food is on the set, the prop stylist should stay nearby in case items need to be changed or moved to create a totally harmonious image. When the photographer and client are happy with the set, then the prop stylist should begin preparing for the next shot. After the shoot is completed, the prop stylist must clean and repackage all props, and handle the return of rented or borrowed items. If room sets were built, the prop stylist dismantles them, stores them in the studio, or returns them.

note

The stylist must organize all receipts for returns and client billing. Keeping peel-and-stick labels and a good marker on hand to place on packages or bags when using messengers is a good practice. After completing all the returns, the prop stylist calculates the final cost of props for the client's invoice.

Understanding Style

One of the most important characteristics of a good prop stylist is a keen understanding of style. The stylist can choose an array of props to evoke many themes such as modern, contemporary, traditional, ethnic, futuristic, or surreal. They can also use props to stimulate emotions—serious, dreamy, romantic, or playful.

Once the style of a picture is decided, work begins on design. Each shot has a key element, which is why no two shots are ever the same. The key elements are affected by how the shot is going to be used in the layout—vertically or horizontally, how the camera will "see" the set, and how the food will be placed on the dishes. To achieve the desired design, the prop stylist needs to understand how the elements of color, size, texture, and patterns in the food are affected by the dishware, silverware, flowers, glasses, plates, and backgrounds.

For example, in creating a vertical shot where the key element is in the center, the prop stylist will create the set from the center out. The stylist will place the featured dish in the center, and then fill in the shot by placing smaller or lower items in front of the dish and taller items in the background—never using items that will distract from the featured dish. The prop stylist builds the set around the featured item and helps create the final vision. In this way, prop styling is a little like baking a cake. At first, the cake is simple, but then it is decorated delicately, always keeping in mind balance, color, texture, and overall design.

Color

Color is of utmost importance when styling a shot. The color of the food, or the color scheme of a setting, will determine what props can or cannot be used. Many prop stylists create their own personal notebooks, which contain Pantone sheets, fabric swatches, and paint tabs, to help them in the process of selecting complementary props. These can be especially useful in larger photo shoots.

tip

When speaking to the client, it is very important to listen for specific words or phrases that describe a color or mood—for example, "earth tones," "vibrant colors," "rich tones," "pastels," and so on. This is especially helpful when clients are unable to name a specific color.

tip

If gels are used to change the color of the light in a scene, the color of the props also will be affected. The prop stylist and the photographer should work together when it comes to the selection of gels.

Size and Proportion

Common sense is not always the order of the day when deciding what size plate should be used with that piece of fish you are shooting. From the photographer's perspective and angle of shooting, a 10-inch dinner plate could overwhelm the photograph; a six-inch salad plate may be a better choice.

It is up to the photographer and client to decide at what lens perspective and angle the camera is "seeing" the set. Adjusting the size and front-to-back position of props is another technique that can affect the apparent depth of a photograph.

Food

Now for the key ingredient: food. Depending on the client's vision for the shot, food can be viewed as provocative, fun, or simple, yet it must always look appetizing and delicious. Placing the props so they maintain harmony and balance with the food is critical.

A Visual Comparison of Prop Styles

In the past, food photographers emphasized a very refined, formal approach to design. Stylists dressed tables with multiple layers of fabric, linens, and ornate decorations that suggested luxury and elegance. In recent years, however, photographers and stylists have moved away from this look. Today's magazines, advertisements, and cookbooks emphasize simplicity, natural beauty, and an organic feeling. Photographers shoot at close range, zeroing in on a specific ingredient or element of a dish. As a result, the prop stylist must be able to determine which props work best with very small elements of food, as well as larger scenes. The following examples illustrate differences in approaches to prop styling.

Poached Pears

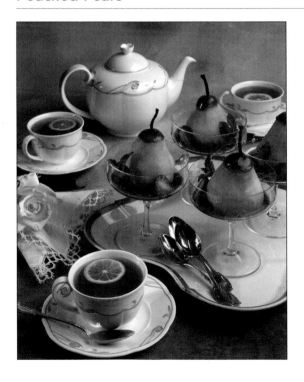

1. Photographed nearly 20 years ago, this shot portrays the old fashioned style of dressing a table using a hand-painted canvas as the surface and backdrop. The antique dishes and flatware underscored the muted tones and regal setting. Although this approach was typical of the time in which it was done, looking at the image today we can understand that the pears are lost in the photograph, and not the main focus of the shot.

2. This more recent shot shows only a single serving, with minimal propping and contrasting color to set off the pear. The modern dishware and horizontal lines in the linen lend texture to the photograph. The cinnamon sticks add a balance of natural ingredients, the perfect touch to create this contemporary feeling.

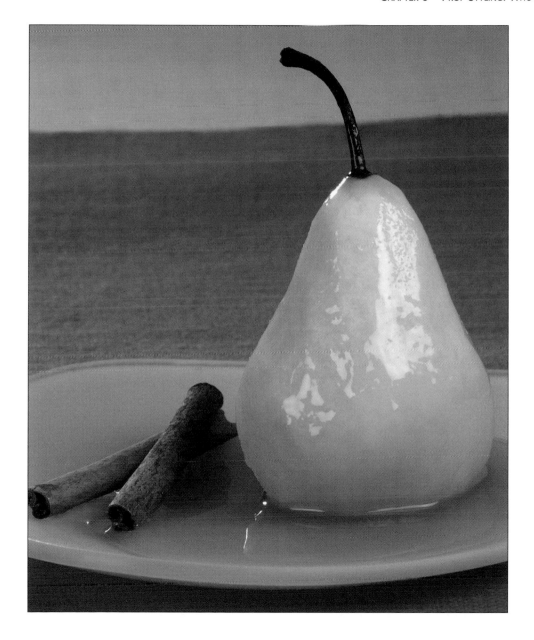

Fresh Fruit Tarts

1. A variety of fresh fruit tarts, whole fruit, wicker baskets, a champagne bottle, and terra cotta tile create ambience in this photograph, which was shot more than 15 years ago. The tarts and props are arranged on and among the baskets, giving the picture a casual, rustic feeling.

2. This photograph exhibits a much more modern approach. No props were used in this image. It was shot at a much lower angle which helped to give it a cleaner and more dynamic look.

Tuscan Bread

1. To create a warm, rustic feel for the breads in this photograph, the stylist used "old Italian" linens and an inlaid wooden table, filling the background with dishware and glasses. The photograph was shot with soft, yellow lighting to intensify the warm mood.

2. In this image, the client wanted a single, hearty roll to be shot in a modern fashion that emphasized the organic elements of the bread. A simple blue and white–patterned napkin was used, with contrasting small red grapes to add a splash of color and appetite appeal. Selective focus was used to intensify the texture of the roll.

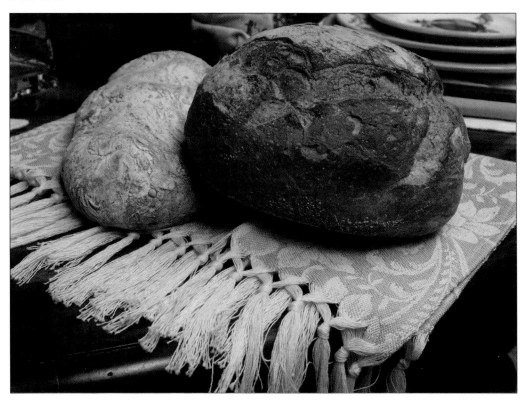

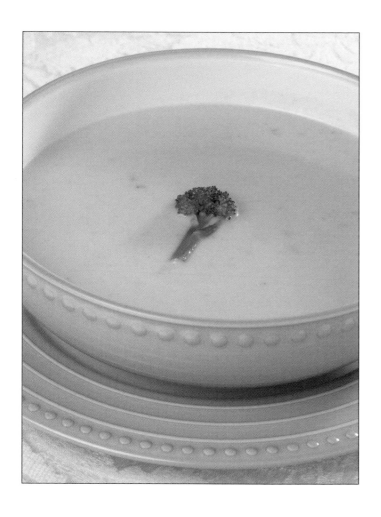

Creamy Cheddar Soup

1. In this single-serving shot of a creamy cheddar soup, the client wanted minimal propping and a simple color palate. An off-white terra cotta bowl and plate with a textured rim was selected first. After several attempts, the photographer, client, and stylists agreed that the muted colors of the props were too similar to the soup, causing the broccoli to be the image's primary focus.

2. Because the first shot was too monochromatic, the prop stylist used a backup idea for the soup. The blue-on-blue bowl and plate, with the textured light blue linen surface, coordinated perfectly with the soup, allowing it to be the true feature of the shot.

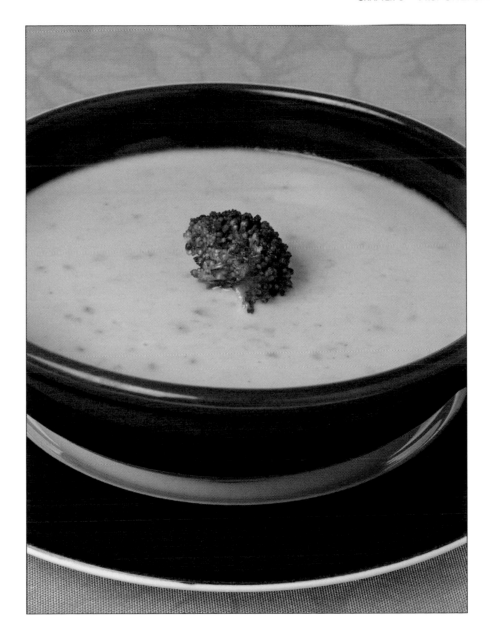

Fresh Lemonade

1. These pictures were taken for a magazine article on summer beverages. The original concept was to take the shot in my studio using minimal props. The client and I agreed that this approach did not capture the vision we wanted to achieve.

2. We took the lemonade and props to a nearby park in New York City (we brought some extra lemonade because it was a hot day) and shot outside on a patch of grass. Natural sunlight and a reflector were used to reinforce the refreshing and bright appearance of the subject.

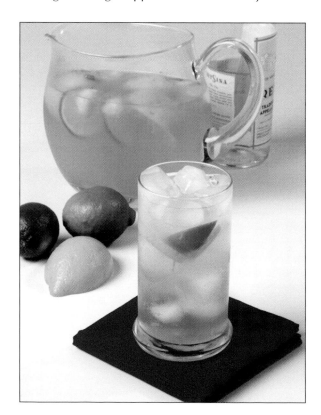

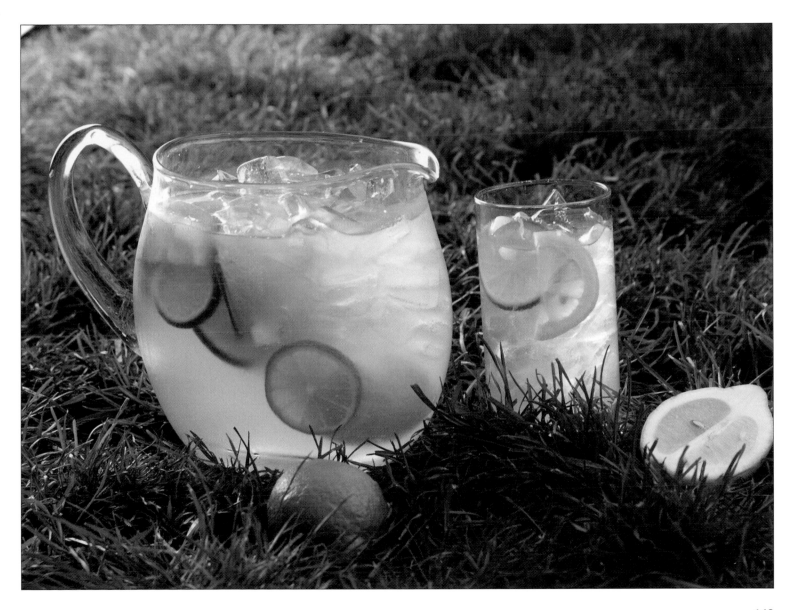

Kid's Birthday Party

1. To feature a cupcake recipe for a children's party, the client wanted to shoot a full-room scene using color-coordinated plastic plates, cups, utensils, and paper napkins. This set did not work because it dwarfed the cupcakes.

2. The stylist changed the entire setting, departing from the previous formal setting to a more fun, lively, and casual buffet. The cupcakes were brought to the center of the photograph, making them the main feature—but they are still overwhelmed by the props.

3. It is not unusual for a set to be changed several times before the perfect shot is achieved. In this case, the clients chose to omit the set and focus exclusively on the cupcakes.

Italian Aromatic Herb Dinner

1. This is the prop stylist's table prior to the shoot, laid out with all the plates, napkins, and decorative pieces that might be used. Post-Its identify the plates that will be used for specific dishes. This keeps the shoot organized and efficient.

2. This shot combines a full table setting with a modest background. Fresh herbs in clay pottery, along with greenery and flowers, help create a bright, spring-like mood. A table runner was used in place of a tablecloth to create a more modern look.

3. Each place setting features white square dishes and straight lined flatware, which are complemented by the square candle votives and clear glassware. The earthy orange tone of the napkin is echoed in the wood of the table, in the clay pottery, and in the candle.

4. The clean lines and casual, lively mood of the props enhance the lightness and appetite appeal of the dish. Garnishing the food with a sprig of fresh Italian parsley helps tie in all the elements to achieve the client's vision of a unique and imaginative dining experience.

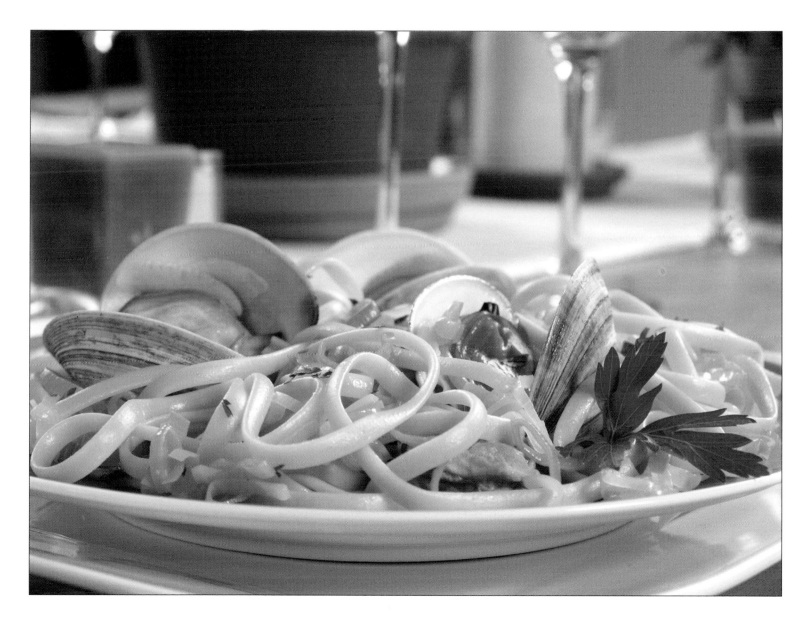

Wine Dinner

1. This shot shows a single setting with layers of fresh natural tones and muted yellows. The stylist chose to match the linen napkin and placemat. The candles give a warm glow to the glass balls, while the rounded edge of the plate offsets the circular shapes in the photograph. A wild flower provides color contrast, creating depth and a more interesting focal point.

2. The fluted magenta-colored glasses harmonize with the wine bottle and decanter. The table linens, placemats, and decanter contrast with each other.

3. A tall vase filled with stained glass balls creates a magical mood, and reflects pinpoints of light from the candles and from the photographer's lights.

4. Stalks of rhubarb are submerged in the tall vase centerpiece, and colored pillar candles help balance it visually. The different heights of the candles, smaller vases, and glassware add dimension to the photograph.

Cannellini Beans with Sage

1. The client's vision was to create a romantic holiday mood using minimal props and a modern look. The stylist used a dark table surface and rich red linens to create a feeling of soft elegance.

2. The first shot did not work for the client because it was too Spartan, so the stylist pulled all the props closer. The camera angle was changed and focused tighter on the dish. This still did not meet the client's vision.

3. The prop stylist rearranged the candles, flowers, and other table dressings to add to the romantic mood, and the camera angle was lowered to showcase these new props.

4. The prop stylist added a gift box to the left of the dish. The gift and bow balance the table dressing in the background, and complete the client's vision of a romantic holiday dinner.

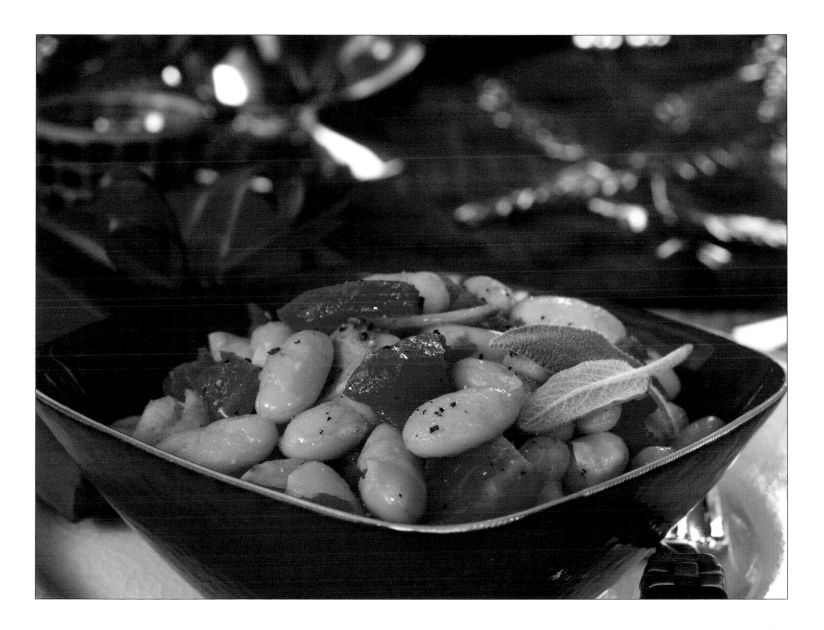

Almond Cookies

1. In this shot, the stylist used a limited number of props and the shot was taken at a close angle, cropping out most of the environment. It did not work because the height of the pedestal was not apparent, and the shades of brown competed too much with one another.

2. In this shot, more of the background was shown, including a wood paneled buffet lit from below. Adding raspberries to the pedestal and opening the linen napkin created contrast and a better sense of proportion.

3. Shooting from a farther distance and lowering the camera angle created a romantic feeling by showing off the elegance of the pedestal and the earthenware in the background. The glasses were moved to the right of the almond cookies for symmetry and balance.

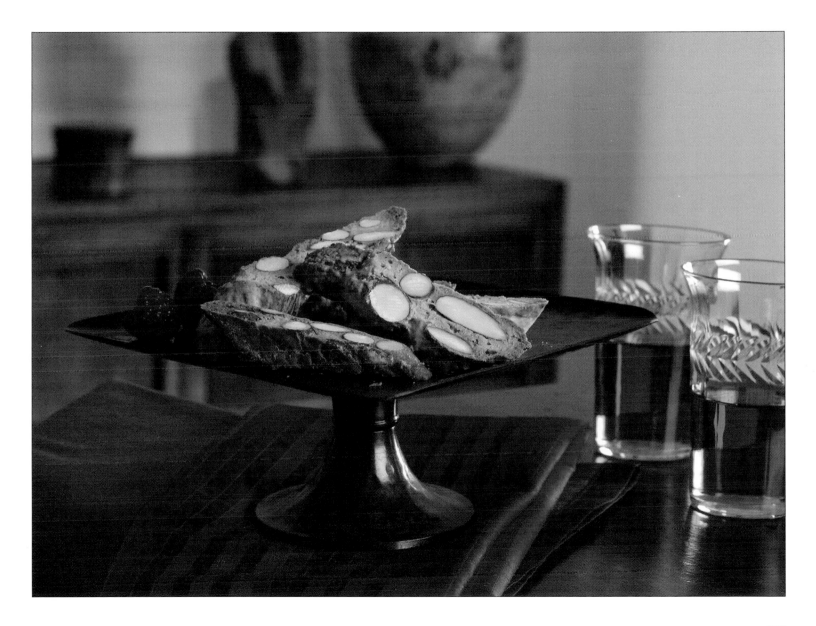

Chestnut Dinner

1. This first photograph shows a formal table setting with a full background environment including a piano, fireplace, and buffet table. The stylist combined rich, red linens with white china to emphasize the elegance of the setting. Candles, roses, and mirrored mosaic votives create a warm, romantic mood.

2. A partial table setting is seen in this photograph, which narrows the view to two guest chairs. The camera angle is lowered and focused on the setting itself.

3. This shot of a single place setting shows the clean lines and complementary shapes of the glassware, dishes, and napkin ring. The small brocade pattern on the linens gives the set a contemporary touch.

4. This close-up food photograph was shot on the same set with a telephoto lens at a wide f-stop to achieve a soft-focus effect. The hint of a lit candle in the background adds that romantic touch.

Roasted Chestnuts with Mulled Wine

1. The prop stylist used a stack of woven, dark wooden boxes as a backdrop for this shot. However, the geometric shapes proved to be too distracting from the dish and the color was too monochromatic.

2. The stylist added a deep cherry red pillow to create more visual interest. Although it definitely added more color, the large pillow also proved to be distracting.

3. In this photograph, a portion of the pillow was covered with a patterned scarf, which helped break up the background red hues. However, it still took away from the dish itself.

4. The stylist moved the scarf to the right of the dish, so that it appeared to be more of an accent in the shadow. This placement complements the warm ambience of the dish and set. It is more subdued than in the previous images, while still maintaining color and texture. The food stylist added a touch of cinnamon powder to the dollop of fresh whipped cream, which intertwined all the colors. I added a mirror to give a reflection of light to the side of the coffee mug and make it stand out more from the background.

CHAPTER 6

Grabbing Your Attention: Composition

Composition refers to the arrangement of various forms, shapes, textures, colors, and elements in a photograph. Think of it as trying to put a puzzle together, with pieces that are not precut to fit a certain way. There are a variety of techniques for composing good photographs depending on the subject matter, including the following:

❖ **Spiral.** People in Western cultures read from left to right, and we've trained our eyes to scan other things, including images, in a similar left-to-right sweep. Our eyes naturally tend to scan pictures in a clockwise fashion and then spiral in to the area that has the whitest and brightest colors at its center.

❖ **Lowercase "a".** Thinking about the shape of a lowercase "a" is helpful in understanding the principles of good composition. It is a simple shape that acts as a guide for the eye. The "a" leads the eye in a clockwise fashion, similar to a spiral, pointing it to the main subject, which is slightly off-center.

note

If you keep the "a" in mind, you will automatically create interesting compositions. This will help you balance the elements in a photograph, creating a yin-yang effect.

❖ **Bullseye.** This is an old-fashioned technique of placing the key element smack in the middle of the photograph. The use of concentric shapes pulls your eye into the middle of the photo.

❖ **Rule of thirds.** Okay, this is not necessarily a rule, but it is a great suggestion that really works. Think of a photograph as divided into thirds, either vertically or horizontally, like a tic-tac-toe board. The idea behind this type of composition is to place the key element in the shot at one of the four intersecting points, away from the center. Composing pictures this way helps make them more dynamic.

❖ **Camera tilt.** A simple tilt of the camera can help composition because it places the subject slightly off-center and creates movement and visual flow. To illustrate the effect, examine the following two photographs. The first example is a typical public-relations shot—straight on, with the bottle's label partially obscured. In the second example, tilting the camera slightly and shooting from a downward angle results in a much more contemporary feeling. The first image is static and rigid; the second image is fluid. This approach goes nicely with the brand's upbeat positioning, and significantly improves the visibility of the label.

❖ **Framing.** Use the outer area of your photos to frame the image and to draw the viewer's eye into the picture. Try to use darker elements near the perimeter and lighter ones in the key areas.

tip

Avoid using too many objects that crowd the space. Try to keep it simple! Like most things in life, simplicity works best. Determine the key mouth-watering element in your image, and compose your photograph to draw the viewer's eye to it.

Although good composition is something that people can learn through practice—and the experience of observing many images, movies, TV shows, and fine art pieces—it is also an inherent skill. Some people just have a knack for it—and they may not realize how or why it works. That said, make it a point to study images that particularly "work" to determine how they are composed. Realize, too, that all rules are made to be broken; you may create just the image you want by turning these rules of composition on their ear!

 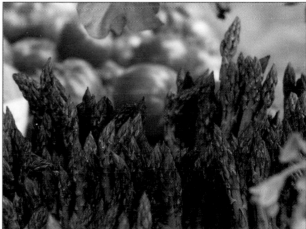

Impact and Proportion

When you look at an object in real life, it is three-dimensional, and everything that surrounds it provides a sense of proportion and scale. In a photograph, everything is translated to a two-dimensional space and reduced in size—resulting in a loss of quality and detail. One of the major mistakes that beginners typically make is shooting too far away from the subject, because they look through the viewfinder and try to replicate what they see with the naked eye. Instead, I like tight shots that are full of impact. They give viewers a sense of perspective and reality that is different from their normal viewing experience.

Often, I accomplish this with a telephoto lens. A telephoto lens makes things look closer than they are. It also, however, compresses the distance between objects and narrows the field of view. Using a telephoto lens is like looking through binoculars or a mini-telescope. You can simulate this effect by using your hands to cut off part of your peripheral vision, reducing your angle of view as blinders do on a racehorse.

 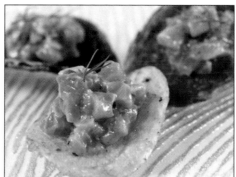 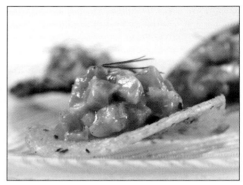

tip

When using a telephoto lens, you must back away from the subject and hold the camera steady. Because telephoto lenses are heavy in general, it's hard to shoot handheld at a slow shutter speed. The best solution is to use a tripod, or to brace the camera on a solid surface.

In addition to using a telephoto lens, employing a low angle and shallow depth of field helps give a picture impact. These are perspectives from which people don't normally see their food, because they usually sit at a table and look down on it. Combine these approaches with an interesting composition and you'll have a great photo!

tip

Good cropping techniques can also help fix compositional problems by eliminating unwanted material from the final image. That said, it is better to frame the photo properly when taking the picture than to rely on cropping afterward because superior final quality is achieved by using the full surface area of the camera's sensor to capture the image.

Depth of Field

Depth of field refers to the area seen by the camera lens within which objects are in focus. Narrowing the depth of field can improve the composition of a picture because your view is limited to just what the photographer wants you to see. This technique directs the viewer's attention to what is sharp, using other, out-of-focus elements to complement the subject, add visual interest, and provide a softer, warmer feeling to the photograph. Sometimes, even a mistake in the background can look good when it is shot at a low angle and thrown out of focus!

The three factors that determine an image's depth of field are as follows:

❖ **The f-stop used**. A wide f-stop, such as f2, 2.8, 4, or 5.6, gives you a shallow depth of field, with less area in focus. Conversely, a smaller f-stop, such as f11, 16, or 22, allows you to get more area in focus.

❖ **The type of lens (normal, wide angle, or telephoto) used**. A telephoto lens using the same f-stop as a wide-angle lens will have less depth of field. Because a wide-angle lens has a wider angle of view, more is in focus. It is easier to achieve selective focus with telephoto lenses because they have less depth of field.

❖ **The distance from the camera to the subject**. All things being equal, there is less depth of field when the camera is focused on a subject that is close to it than when it is focused on a subject farther away.

In addition, shooting at a low angle can provide more depth in a photo. Because a greater front-to-back distance is visible in a low-angle photo, backgrounds will be out of focus if they are farther away.

A Visual Comparison of Compositions

In the past, food photographers strove for images with sharp detail throughout. It is still often a desired effect, which can be achieved by using a small f-stop. Today, we also see selective focus used in food photographs to emphasize a portion of the subject or to create a mood. Let's pick apart the composition of some photos. I'll explain what makes them work and how I achieved the desired effect.

Fruit Tart

1. This photograph and the one that follows, taken for the French Culinary Institute, are examples of how depth of field can change a mistake into a positive picture element. If you look carefully here, you can see the orange clamp holding the reflector in the background.

2. Throwing the background out-of-focus hides the clamp, but at the same time allows its color to balance colors in the foreground. The parallel line of the clamp also reinforces the diagonal composition of the photo, a serendipitous effect. Sometimes, you just luck out!

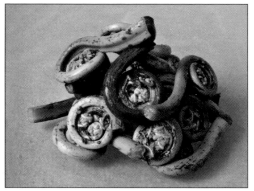 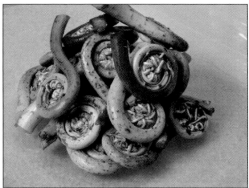 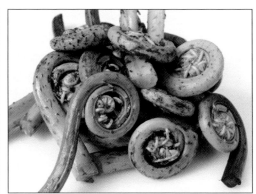

Fiddlehead Ferns

1. When faced with photographing a variety of similar objects, you can bunch them together. In this example, I was trying to show the variations in the color and size of fiddlehead ferns. A problem in this picture is that the ferns look very small and almost entangled with one another.

2. I rearranged the ferns to give them a tighter, more circular composition and more definition to their distinct features. I came in closer and changed the angle of the photo to give it more impact. However, I felt that the ferns didn't stand out against the muted green background.

3. Going to a white background and brighter lighting provided more contrast, but it was too stark and clinical for these delicate greens. I continued to work with a circular composition, but because of the shape of the ferns, there were too many conflicting circles.

4. I decided to break out of the traditional composition by focusing on one hand-held fern, putting the others in the background out of focus. I also rearranged them in a more linear fashion. The sharp focus on the fern in front makes the intricate detail stand out, while maintaining the feeling of shape, softness, and movement in the background.

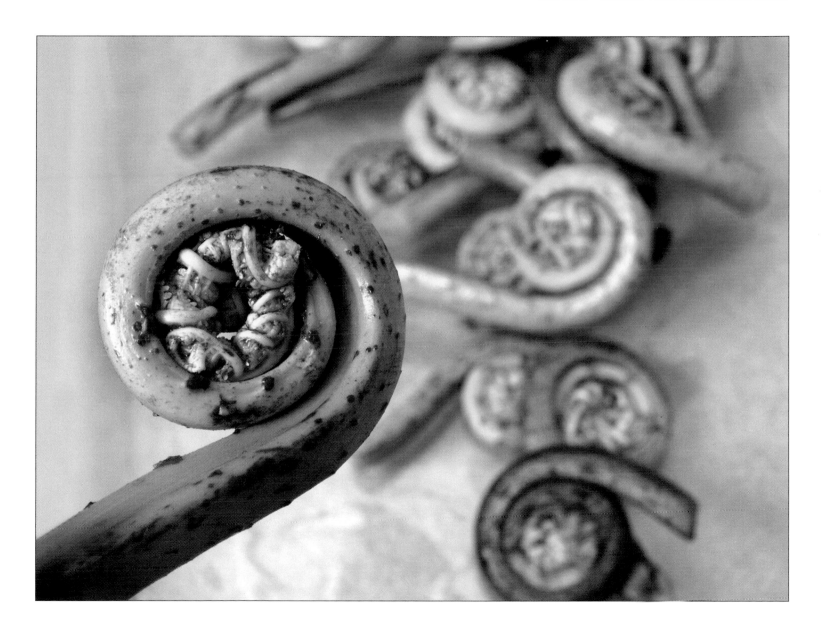

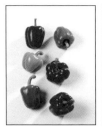 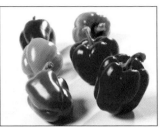 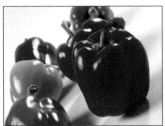 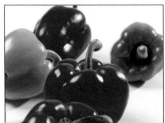

Tri-Color Peppers

1. I started by placing a variety of peppers in rows and shooting straight down on them, because that was what the client wanted. As you can see, it doesn't look too interesting, with a stagnant composition of two vertical, parallel lines. There really isn't much movement or visual flow to the photograph.

2. As I lowered the camera angle on the same arrangement, without moving the peppers at all, I achieved a much nicer photograph, but it was still too linear.

3. Lowering the angle even further, while tilting the camera, makes the photo even more interesting, although it feels like the peppers are sliding off the page. Thanks to the highlights in the peppers, however, we are starting to create the shape of a lowercase "a" on its left side.

4. This picture is much more pleasing to the eye. It has a better feeling of stability, the colors contrast well, and the composition becomes more circular with the middle pepper in the bullseye position.

5. Lowering the camera angle, focusing on just two red peppers, and using shallow depth of field to blur out the back pepper make this photograph much more dynamic and sensual than the previous ones. The monochromatic simplicity is pretty, but it's just not interesting enough.

6. Now we're talking. A much tighter composition, using shallow depth of field, colors, shapes, and highlights in the peppers, creates that "a" shape more clearly. This photo is much more inviting and uses the pepper stem to point your eye in the direction of composition.

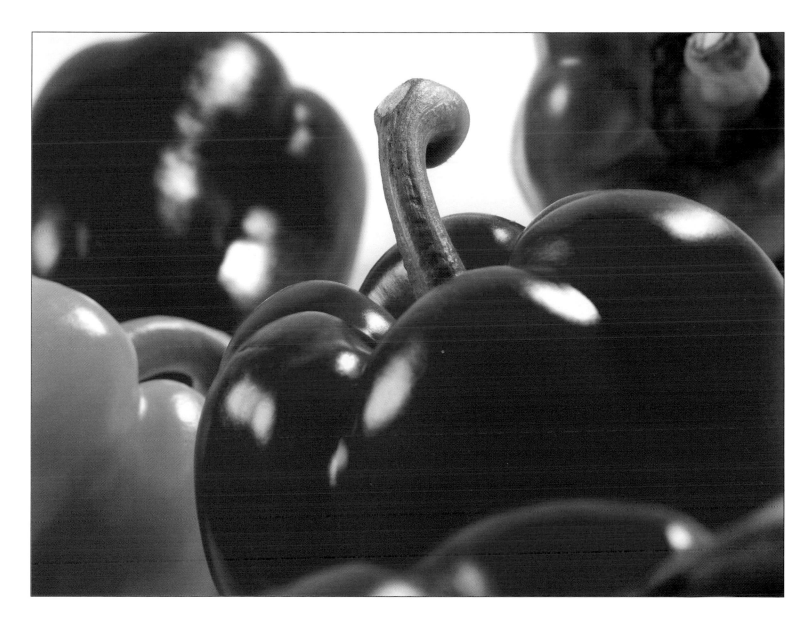

 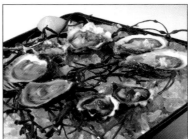 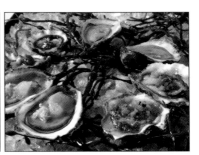

Oysters

1. This image is similar to the peppers in that it simply represents four varieties of oysters shot from overhead. The composition is too linear, and you can almost see the parallel lines running diagonally from the top-left to the bottom-right corners of the picture.

2. I rearranged the oysters, and used their shapes to give the picture a more circular composition. But this picture is too stark. Oyster shells on a plain white background are pretty, but have no appetite appeal.

3. The chef added ice, seaweed, and a lemon wedge to create a more appetizing image, but the angle is too wide, and the oysters are spread out. The arrangement is much too circular. The edge of the tray also is distracting. In addition, the subtle difference in the shapes of their shells is not apparent.

4. I moved in closer, but the oysters are still arranged in a circle, and the seaweed is center of attention.

5. I tightened the shot even further and broke the circle. This arrangement results in a distinct lowercase "a" composition with the most interesting oyster shell the center of attention, framed by the vibrant splash of color in the cocktail sauce and lemon wedge.

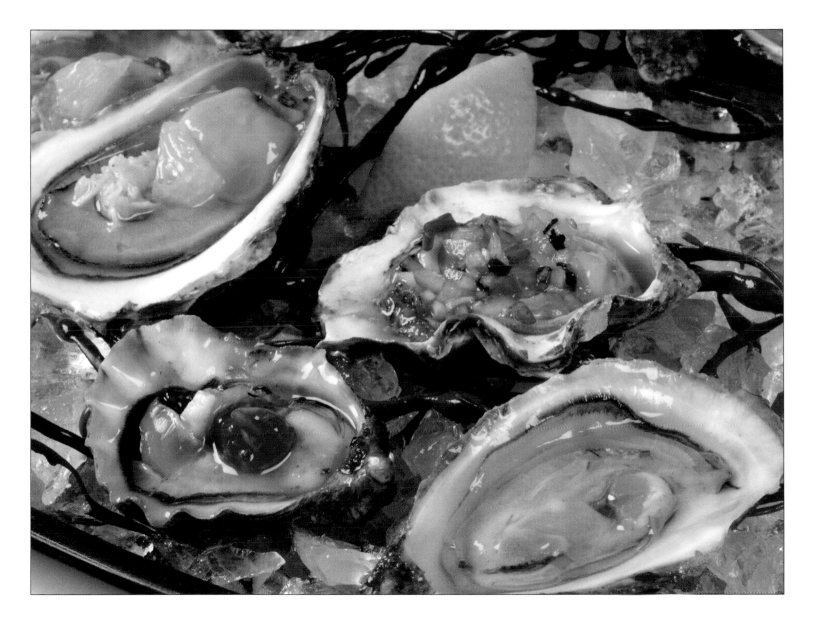

Anchovy Salad

1. I started shooting this salad sequence at a low angle because I was amazed at how the chef was able to pile the food so high in the bowl. The picture doesn't work, though, because you can't discern the anchovies or the bread.

2. I raised the camera angle without rotating the bowl. I was concentrating so much on achieving a circular composition, however, that I missed the hook-shaped lettuce leaf on the right until I reviewed the image on the monitor. Another plus for the immediacy of digital photography!

tip

In composing your shots, concentrate on the part of the image that you feel is most important, but don't forget the small details!

3. I rotated the bowl clockwise and moved up to a slightly higher angle. I started to get a triangular shape to the salad, and maintained the circular composition, which is defined by the shape of the bowl. That pesky lettuce leaf is still there, however.

4. I rotated the bowl counterclockwise, because this was a better angle to see the salad and anchovies. Once again, the bowl keeps your eye moving around the photograph in a clockwise direction.

5. Then, I tilted the camera. That was a mistake, because the angle is so steep, it looks like the anchovies are going to slide right off the top.

6. Finally, I tilted the camera just slightly in the other direction. This photo combines the best parts of all the previous images into one. The salad looks tall, the anchovies direct your eye clockwise, and there is a very distinct triangular shape, which accentuates the elements in the salad.

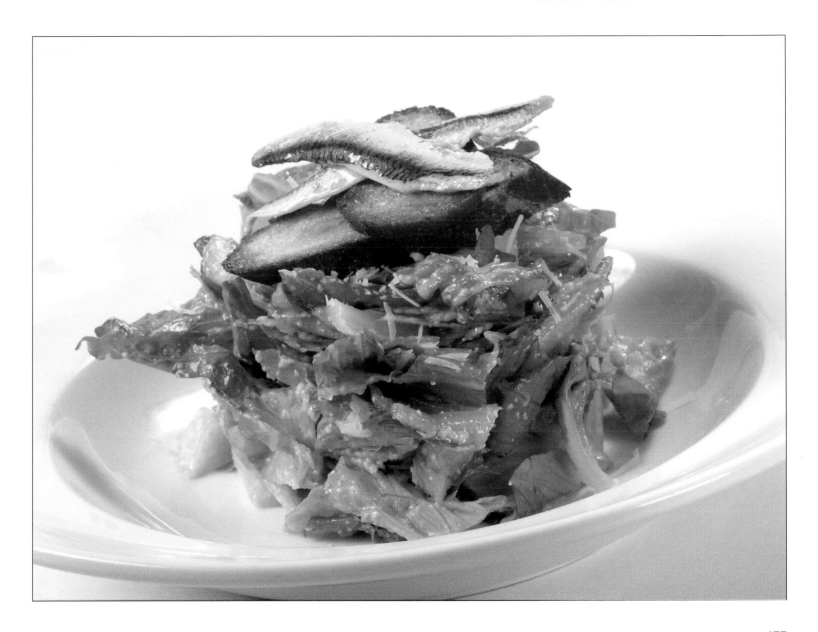

Spring Pea Risotto

1. This was a beautiful dish because the shrimp have a spiral shape and their grilled color and texture is so appealing. They are set off beautifully by the green peas in the risotto. That said, the shot is not as compelling as it could be because the individual shrimp are not well defined and the food is too deep in the bowl.

2. I tried a slightly higher angle and rotated the bowl counter-clockwise to get a different view of the shrimp, but the angle hid some of the shrimp.

3. I went in very close, but that placed too much emphasis on the one large shrimp in the center. There isn't enough negative space to help the eye go into a spiral scan. This is a good shot, but very traditional, and it just feels too close.

4. I tried a direct overhead shot. The shrimp tail on the left looks like it's not attached to anything, and it points your eye up and out of the frame. The middle shrimp is smack dab at the center of the image and it appears too flat—there is just no dimension to it. And because your eye wants to read left to right, the counter-clockwise spiral of the shrimp directs your eye out of the picture instead of into the center.

5. Finally, repositioning the shrimp and angling the camera for a different approach gave more depth to the picture. The negative space of the bowl leads the eye from left to right into the tail, to follow the spiral shape of the shrimp into the risotto. The positive space—occupied by the shrimp on the lower right—plays against the negative space in the upper left.

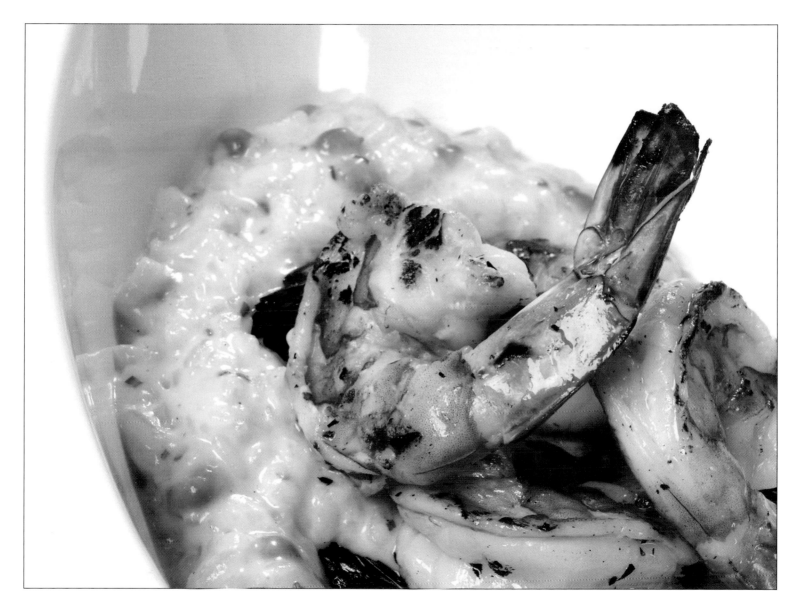

Oven Roasted Mussels

1. This picture doesn't work at all. The bread dominates the dish, and you can only see the meat of one mussel. The dark shells are not appealing, and the food is too deep in the bowl.

2. The chef added more mussels. I tried an overhead angle to show the meat inside the shells, but they were still half-closed, and the photo doesn't really show the depth of the bowl.

3. I opened the shells further and lowered the camera angle. This gave the food much better height, shape, and visibility. The angle of the bread and the shape of the bowl now give the image a very distinct oval composition.

4. Next, I tried a close-up since there was so much negative space in the previous photo. This didn't work because it did not give the viewer any sense of quantity, and I wanted to show that the dish was brimming with mussels.

5. This image gives a much better sense of the amount of food in the dish and the size of each mussel in its shell.

6. I tightened up the shot and lowered the angle slightly. Then I adjusted the position of a mussel to fill in a gap in the previous image. This is a nice, tight, circular composition, with a red and black bullseye right in the center.

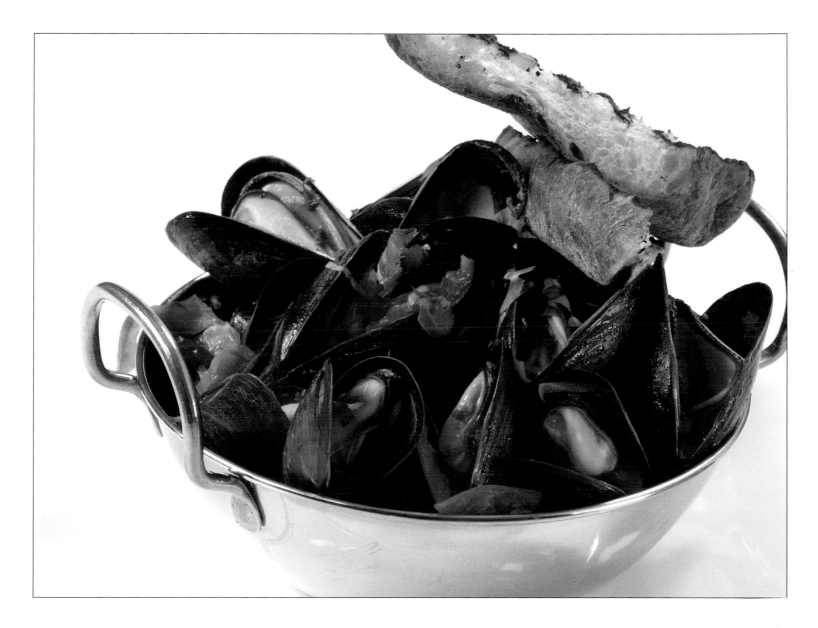

Beet Ravioli

1. This shot was taken on location with available light to illustrate a newspaper article. I used a shallow depth of field to make the front beet ravioli stand out from the other ravioli in the background. The rim of the white plate provides a frame around it.

2. I didn't like the shape of the front ravioli in the previous photo, so I rotated the plate to show a different ravioli framed by its out-of-focus counterparts and the white plate. I placed this ravioli at the lower left section of the "tic-tac-toe" board to add visual flow to the photo.

3. I felt the ravioli was not standing out enough. I decided to go in another direction—placing the ravioli in the back of the photo and throwing the foreground out of focus. The rim of the plate frames the image from above, and the darker colors contrast the sauce in the background.

4. By rotating the dish once again, I was able to achieve a much prettier shape, design, and reflection of light. Now the ravioli really stands out—framed perfectly by the white plate on top (where your eye starts reading the photograph), the prominent yellow sauce, and the out-of-focus ravioli in the foreground. You really want to reach into the picture and grab it!

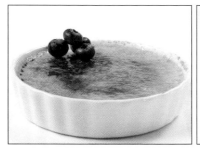 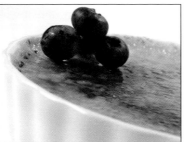 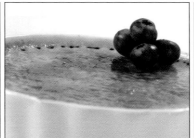 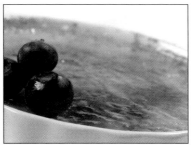

Blueberry Crème Brûlée

1. I started with a standard composition showing the entire dish at a level angle. There is no movement in the image—the blueberries look like they are just sitting on top of a flat surface.

2. I tried a close-up on the blueberries, but they overpower the image and become the focus of attention because of their placement in the center of the image, their triangular arrangement, and the sweep of the dish's rim.

3. I rotated the dish, which moved the blueberries off to the side, and I pulled back to show more of the crème brûlée. The edge of the dish gives the image an oval composition.

4. I still wanted to do something with those blueberries. I rotated the dish, tilted the camera, and raised the angle a bit to open up the oval composition. However, the steep angle makes it look like the blueberries will roll off to the right.

5. I kept the same camera angle but rotated the dish back. Now, the blueberries balance the composition and are anchored at the bottom of the picture. They help create a frame in the foreground to keep your eye in the middle of the soft-focused crème brûlée.

 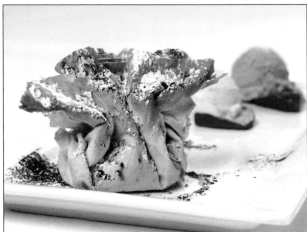

Phyllo Purse

1. I took this photo with a wide-angle lens. The scoops of ice cream appear as large as the phyllo purse in the background, and there is too much distance between the objects because the wide angle lens exaggerates perspective.

2. I reversed the angle of the dish to emphasize the phyllo, but now it appears disproportionate to the scoops of ice cream, which look too far away.

3. I changed to a telephoto lens. This compressed the distance between the phyllo and ice cream, and made them appear in better proportion and closer together.

note

Wide angle lenses make elements in the foreground appear larger than those in the background, and exaggerate distance and perspective. Telephoto lenses, on the other hand, have an opposite effect. They compress distance and make objects in the background appear similar in size to objects in the foreground. Remember that depth of field is shallower with telephoto lenses.

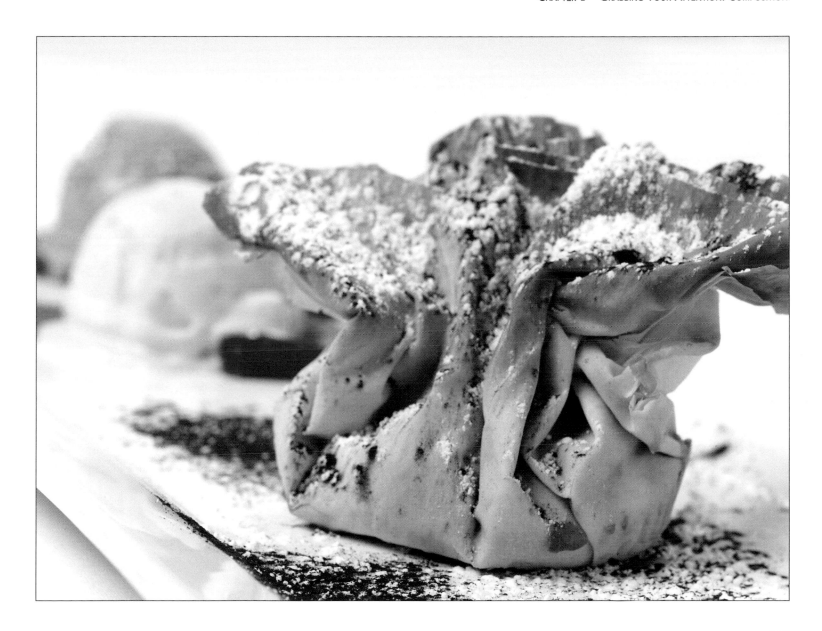

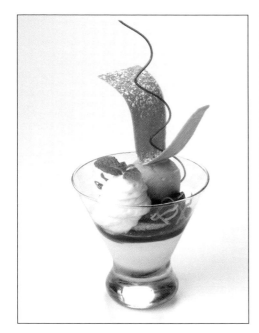

Passion Fruit Sorbet

1. I began with a plain, vertical composition because of the height of the dish and the interesting shapes of the sorbet and garnishes. However, this straight-on traditional angle lacks anything dynamic.

2. A simple tilt of the camera allowed me to get closer, from a slightly higher angle. This angle works with the caramel swirl to point your eye into the sorbet. It helps the composition, but it feels like the glass is going to fall over.

3. Tilting the camera in the other direction and looking down into the glass provides the perspective needed to spiral your eye into the picture and get closer to the sorbet. The problem is that the curl of the wafer blocks the sorbet at this angle.

4. Lowering the angle exposes more of the sorbet. The white negative space gets your eye to start on the left and track clockwise through the upper part of the photograph, while the caramel swirl and wafer direct it back into the sorbet in the center. The overall feeling is much more fun, festive, and exciting.

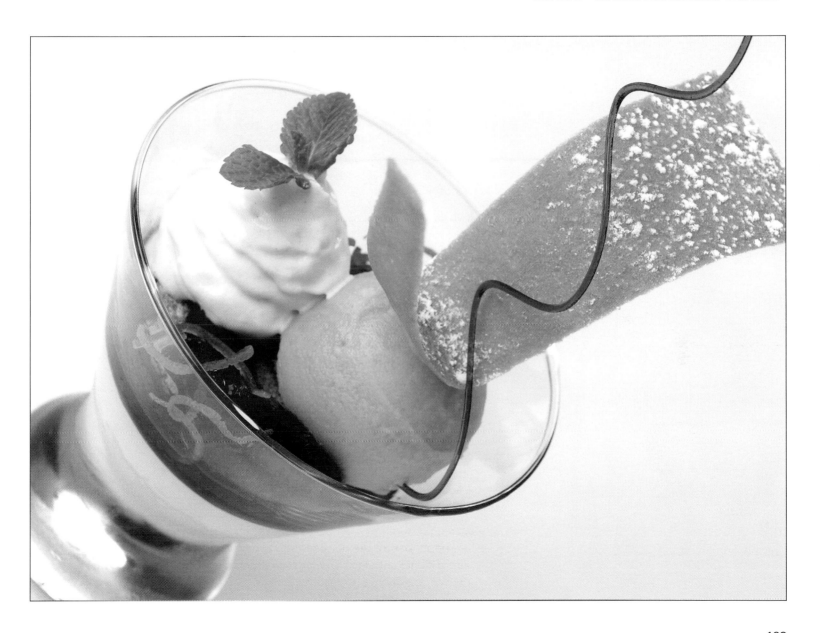

CHAPTER 7

The Recipe for Light

In photography, the importance of lighting cannot be understated. Just as "location, location, location" is the key to real estate, good lighting is essential to any great food photograph. Lighting is the most essential variable that the photographer controls, after all the other professionals and artists have gotten the food and set ready to be captured. Understanding and using lighting is crucial to bring out the best in your subject. Light in its many varieties and moods is, after all, what we as photographers strive to capture. Simply changing the angle of the light can alter its quality and character.

tip

Every object reflects light just as a mirror does: The angle of incidence at which light strikes an object is the same as the angle at which the light is reflected. Keeping this in mind is particularly helpful when shooting shiny objects such as glass, silver, and china.

The Importance of Proper Exposure

Before I get into various lighting techniques for digital food photography, I want to impress upon you the importance of using the proper exposure. Indeed, using the proper exposure is critical to great photography. Having enough detail—especially in the highlights—is a key challenge you'll face in digital photography. Similar to shooting photographs with slide film, shooting digitally requires that you be more precise in your exposure than with negative film. If you don't expose the photo properly, you won't be able to put detail back into the image without devoting an enormous amount of time and energy to retouching. Even then, the image might still not look great.

ISO Settings, f-Stops, and Shutter Speeds

The image sensor in a digital camera is what captures the light in your photograph. Adjusting the ISO (International Standardization Organization) setting can change the sensor's sensitivity. Most cameras default to 100 ISO, which is equivalent to ISO 100 film in a film camera. With the proper exposure, the chip is exposed properly, and a photograph with the proper detail is achieved. A combination of f-stop and shutter speed is used to allow the chip to "see" the amount of light that it requires to render a proper exposure.

To understand how the f-stop setting works with regard to proper exposure, think of the chip in your camera as the eyes of a person waking up in a darkened room. When the person opens the window shade, light is allowed in. If it's really bright and sunny out, the person squints his eyes and his pupils contract so that he can see properly. This is the same as closing down the lens opening in your camera—that is, using a higher f-stop number—to compensate for the brightness of available light or flash. On the other hand, if that same person were to close the shade after his eyes had adjusted to the bright light, returning the room to its darkened state, he might need to wait a moment for his pupils to dilate in order to again see details of the darkened room. This is the same as enlarging the lens opening in your camera—that is, using a lower f-stop setting—to accommodate for low-light conditions.

note

The old textbook analogy to a faucet is another way for you to think about the reciprocal relationship of shutter speed and f-stop. The right exposure is like a bucket full of water. If you run water through a big faucet, you need less time to fill the bucket. With a small faucet, you have to run the water for a long time—the time is the shutter speed, the size of the faucet is the opening of the f-stop. The smaller the f-stop number, the larger the opening and the more light falls on the digital sensor. For example, f4 lets in 4 times more light than f8.

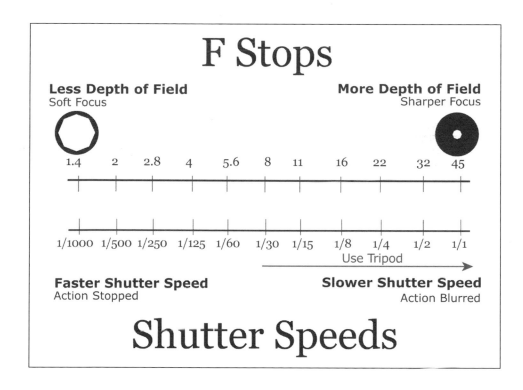

The size of the lens opening and the speed at which the shutter opens are reciprocal factors that affect proper exposure. More light reaches the camera's sensor when the lens opening is wider (a smaller number), so to balance the equation, you must open the shutter for a shorter amount of time to expose the chip properly. As it turns out, the term "shutter speed," which refers to the amount of time that light hits the sensor, is something of a misnomer in cameras. That's because in cameras, the shutter acts like a slit in a curtain that passes in front of the sensor. No matter what the setting is, the slit passes in front of the sensor at the same rate of speed. When the camera is set to a "fast" shutter speed, the slit is very small, so light hits the sensor for only a short period of time. When the camera is set to a "slow" shutter speed, the slit is wide. Because it takes more time for the wider slit to complete its pass, light hits the sensor for a longer period of time.

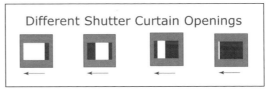

This graphic illustrates that the difference in shutter speed is the size of the opening in the shutter curtain as it moves at the same speed past the sensor.

Let me try to explain this delicate balance of proper exposure again. While shutter speed refers to the amount of time the sensor is exposed to light, the lens aperture, or f-stop, is the size of the lens opening. Achieving correct exposure means finding the correct settings between shutter speed and aperture. If you change one side of the equation, you must make a corresponding adjustment to the other. For example, all other things being equal with regard to light conditions and shutter speed, using a higher f-stop number ("stopping down," for example, from f5.6 to f8) will reduce the aperture size to allow less light to hit the sensor, resulting in a darker picture. There is no effect on action, but depth of field will be increased because the light is being funneled through a smaller opening and is more focused. Using a smaller f-stop number ("opening up," for example, from f8 to f5.6) opens the aperture to allow more light to hit the sensor, resulting in a lighter picture. There is no effect on action, but the depth of field will be decreased because the light flows through a larger opening and is less focused.

Conversely, increasing the shutter speed (for example, from 1/60th to 1/125th of a second), with all other things being equal, will shorten the time that light hits the sensor. Action can be stopped, but the picture will be darker. Decreasing the shutter speed (for example, from 1/125th to 1/60th of a second), on the other hand, increases the time the light hits the sensor; in this case, action will be blurred and the picture will be lighter.

tip

The smaller the aperture opening (for example, f22), the higher the f-stop number, and the more the depth of field, which means more of the background and foreground is in focus. The larger the aperture opening (for example, f2.8), the smaller the f-stop number, and the smaller or more shallow the depth of field, which means less of the background and foreground is in focus. Remembering this will help you understand depth of field and how to get that soft-focus look.

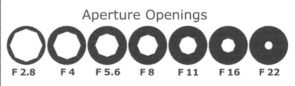

Flash

Illuminating a subject with a strobe flash brings out and enhances the object's colors and textures. The very bright light that the flash provides reveals details that cannot be seen in normal light. I have always preferred this light source when shooting food. A huge benefit is that flash illumination doesn't give off as much heat as quartz halogen lights.

tip

Using mirrors and backlights helps to add dimension, gives more shadow detail, and creates specular highlights on the food or setting. Without these highlights, food photographs lack life and dimension. With them, food can sparkle like jewels. Specular highlights attract attention to the food's freshness, color, and texture, giving it appetite appeal.

In flash photography, you control the brightness of the light by varying the amount of time that the light is emitted by the flash unit. This is called *flash duration*, and is measured in fractions of a second. Using the previous examples, with all other things being the same and assuming you do not change the aperture, a longer flash duration results in a brighter picture. If you use a flash unit, you must make sure your camera's shutter speed is set correctly for flash photography—typically 1/60th of a second, depending on the manufacturer's specifications for that make and model.

tip

You can shoot at a slower shutter speed than the manufacturer recommends, but never at a higher speed. If you do so, the shutter will close before the flash fully exposes the sensor. This will result in a picture that is partially black.

Because you cannot always shoot food pictures in a darkened room, you must account for the effect of a room's ambient light during a flash exposure. For example, in addition to accounting for the light emitted by your flash unit, you may also have to account for any daylight coming in through a window. Depending on what type of ambient light you're dealing with, it can have positive or negative effects on a photo. In particular,

fluorescent lights, which are present in most commercial kitchens, often cast an unwanted green effect on the subject. To counter this, set your shutter speed to the highest flash synchronization speed your camera allows. This will ensure that the green cast of the ambient light will not affect the final photograph because it is overpowered by flash for the entire exposure. Other types of ambient light, such as candlelight or light from a burning log in a fireplace, can help set a mood. In these situations, a slower shutter speed is essential. This ensures that the sensor is exposed to the lower light level of the candles after the flash burst illuminates the entire scene to give the photograph detail.

Metering

All camera exposure meters measure reflective light. They look at what you're photographing and assume that it is an average scene. It is a machine, after all, and expects to see a photograph that has white, gray, and black, as well as other colors and brightness values that balance out to an overall middle gray value.

A reflective light meter measures the light as it bounces off of the subject, so this reading is influenced by its color and brightness. To address this, place a gray card in the photo scene, meter the light that is reflected from it, and set your f-stop and shutter speed to those settings. Alternatively, use an incident light meter. An *incident light meter* measures the light falling onto a subject and simulates a gray card being placed in front of the subject, making it a very useful tool for achieving an accurate exposure.

note

I feel that using an incident light meter is more versatile than using a reflective light meter and a gray card. It allows me to measure the light falling on the subject from all different angles and gives me a better understanding of how the final photo will look. Using an incident light meter, I get a much better understanding of what detail I will get in the highlights and shadows. This makes a very big difference in the final output of the photograph.

example

If you shoot vanilla ice cream in a white bowl with a white background and set the camera on automatic, the ice cream will look gray on a gray background. That's because the reflective light meter in a camera is seeking the proper exposure for middle gray. Thanks to Photoshop, you can correct this wrong exposure, but it is much better to start with the proper one. Even if you are a PHD (Push Here Dummy) photographer, try to think about the tonal range of your subject and compensate for it before you press that button and compensate for it.

This is an example of a gray card.

tip

Did you forget your gray card? Simply hold the palm of your hand in front of the subject, facing the camera, and take a reading. On average, open up one f-stop depending on your skin tone, and you will have the right exposure.

Color Temperature

The color temperature of the light source influences the color that you see in the final photograph. Here's a rundown of the color temperatures of various light sources, measured in Kelvin (K):

❖ **Tungsten (2,600–3,400K).** This standard household light (typically an incandescent table lamp) is warm, with more yellow and red values and fewer blue ones. Quartz halogen light is tungsten (3200K) but has the advantage of staying the same color as it ages. Tungsten bulbs get redder just before they burn out.

❖ **Fluorescent (4,300–5,000K).** As mentioned earlier, fluorescent lights have a green color cast, and really don't help to make food look appetizing. Try not to use a fluorescent light as a main light source.

❖ **Daylight (5,000–6,000K).** Around noon on a sunny (not cloudy) day, daylight contains uniform color values in the visible spectrum. It does vary at other times of the day—for example, warmer color tones at sunset. Studio electronic flash is generally regarded as daylight balance—about 5500K.

❖ **Shade (6,000–9,000K).** Shade has a bluish color cast.

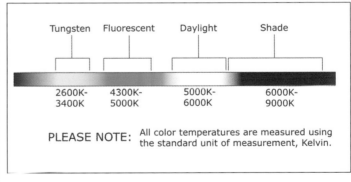

Tungsten	Fluorescent	Daylight	Shade
2600K-3400K	4300K-5000K	5000K-6000K	6000K-9000K

PLEASE NOTE: All color temperatures are measured using the standard unit of measurement, Kelvin.

Although our brains adjust automatically to the subtle differences in this color spectrum, film cameras do not. In the old days, we had to color-balance our film to the light source's color temperature or the photo would come out with a color shift. Now, however, we have digital sensors that can adjust themselves automatically to the light source, a feature called "auto white balance." This revolutionary development has made it very simple for every photograph to have a good color rendition.

That said, I have found this setting to be a bit inconsistent depending on the lighting situation. As a professional, I feel that it is better to set your camera's white balance manually, just as you do the camera's exposure settings. Using a white card, set your camera's white balance so it can take into account all the different sources of light and give you the most accurate color. You don't want your food photograph to look green, do you?

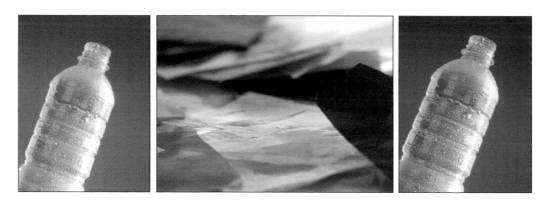

tip

If possible, it's best to manually set your white balance each time you shoot. Alternatively, if you shoot in the RAW file format, you have the opportunity to adjust the color temperature after you've taken the photo. Auto-white balance is a very good setting to use when shooting RAW in any continuous light source. For studio strobe, "daylight" or 5500K is closer.

Lighting Ratios

In digital food photography, it's critically important to control lighting ratios, which refers to the ratio of highlights and shadows on different portions of your set. The higher the ratio, the greater the contrast. Here are some examples of lighting ratios:

- ❖ **1:1 highlights and shadows.** This ratio shows no difference in shadow area, giving a flat look. This isn't favorable at all.

- ❖ **2:1 highlights and shadows.** With this ratio, there is twice as much light in the highlights as the shadows, a one-stop difference. This seems to work well for reproduction purposes.

- ❖ **4:1 highlights and shadows.** With this ratio, shadows are darker, and less detail is shown. This is a two-stop difference.

Lighting for Digital Food Photography

Basic Lighting Tools: Low Budget

If you don't have much of a budget for lighting equipment or access to any lights, you can shoot a nice photo of food utilizing window light. Use reflectors made out of aluminum foil, mirrors, white cardboard, and even the lids from takeout food containers to fill in the shadows and achieve an appetizing effect. To soften harsh shadows from direct sunlight, have a friend hold wax paper or a sheer white cloth approximately a foot above the food.

Depending on how much light is coming in the window, you may need a tripod. A basic rule of thumb is to avoid handholding a camera at a shutter speed below 1/30th of a second, assuming you are using a 30mm lens. To figure out the slowest recommended shutter speed for other types of lenses, just make a fraction out of the lens's focal length in millimeters. For example, a 100mm lens shouldn't be used without a tripod at a shutter speed below 1/100th of a second.

tip

Avoid using direct flash. It flattens the subject matter and doesn't make food look appetizing. Instead, try using flash fill when you shoot outdoors in sunlight to show some detail in the harsh shadows. You can also use a collapsible reflector disc to bounce sunlight back onto your subject and soften the shadows. These reflectors come in various sizes and colors.

Basic Lighting Tools: Medium Budget

Portable flashes are helpful in shooting on location and can be used in a similar fashion to studio strobe units. A very simple flash lighting technique is to bounce the light off of a white card. Another is to bounce the light off of the ceiling or a wall, but be aware of the color of these surfaces; they'll influence the color of the photograph.

You can use a flash extension cable that allows the flash to be away from the camera. Try placing a mini soft box or holding some diffusion material to the side of or slightly behind the food. You'll need to use some reflectors or mirrors to assist you in achieving the desired results. Of course, since you're shooting digitally, you'll get instant feedback on your lighting attempts.

I often use a portable double flash technique when shooting on location. My fill flash is on a bracket over my camera or slightly off to the side. I place another flash on a stand with wheels off to the side or slightly behind the subject to get more of a three-dimensional effect. In order to set off the second flash, I use a radio slave such as the Pocket Wizard Plus with very good results. You can also utilize an optical slave depending on some factors including your budget. This is a simple technique to give dimension and depth to your image.

Basic Lighting Tools: High Budget

The use of studio strobes, umbrellas, various reflectors, soft boxes, and grid spots is truly the professional approach. There are many manufacturers and a lot of lighting equipment on the market, at all price points. Just check them out and pick one that suits your needs, budget, and use. To help you get started, I recently asked Julio at Adorama Camera's Pro Services desk what simple startup lighting packs he recommended. The Elinchrom 400BX lighting kit was his choice, and the price was right. I bought it and have been testing it with wonderful results. In addition, I've used Norman powerpacks and lights for the past 30 years. They have been reliable workhorses throughout my career. I have most of the heads, reflectors, grids, barn doors, and accessories available.

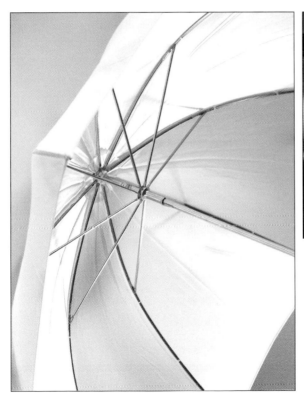

A Visual Comparison of Lighting Setups

Generally, light is more widely distributed when a light source is larger, and the reflections of that light source—seen on the subject as highlights—are larger as well. The shape of the light source also influences the shape of the highlights. For example, a rectangular soft box will create rectangular highlights on a flat glass or metal object like a beer stein or knife, while a round reflector creates more rounded highlights. The difference is not as pronounced on spherical objects, such as fruit.

The following tables illustrate the impact that a variety of reflectors, umbrellas, soft boxes, and mirrors have on the highlights, shadows, contrast, and detail of the same food subject. You can clearly see the exposure range of each light source in the photos that follow. They are documented by incident light meter readings, which show the numerical difference in exposure between the highlights and shadows. It is important to understand what these numbers represent. When the difference between two readings is great, less detail is captured because there is a large degree of contrast between the highlights and shadows. In addition, the shadows become darker and have less detail. The edges do become sharper. For example, when the difference in exposure between the highlights and shadows is three f-stops, the photograph has more contrast and less detail in the shadows than if the difference between the highlights and shadows is one f-stop.

note

As mentioned earlier, it is very important to expose properly for the highlights because it is difficult to put detail back into the image during the retouching process.

The following chart shows the numerical relationship between f-stops. Each box represents a difference of one full f-stop, moving vertically in the same column. For example, the difference between f2.8 and f4, or between f10 and f14, is one f-stop. The difference between f8 and f22, or between f3.5 and f10, is three f-stops. Moving left or right, each box in the chart represents a change of one-third of an f-stop. Simply count the number of whole and one-third f-stops between two incident light meter readings to determine the difference in proper exposure. For example, the difference between f5.6 and f14 is two and two-thirds f-stops. The difference between f2.8 and f5, or between f9 and f16, is one and two-thirds f-stops. The difference between f7.1 and f8 is one-third f-stop, because f8 is one box away from f7.1 moving left to right. Similarly, the difference between f5 and f11 is two and one-third f-stops.

1/3 F-Stop

Full F-Stop

F 2.8	F 3.2	F 3.5
F 4	F 4.5	F 5
F 5.6	F 6.3	F 7.1
F 8	F 9	F 10
F 11	F 13	F 14
F 16	F 18	F 20
F 22	F 25	F 28

PLEASE NOTE: Any vertical shift along the chart denotes a change of a full f-stop.
Any horizontal shift along the chart denotes a 1/3 change in the f-stop.

Let me attempt to make sense out of these numbers through the following tables. The tables have a photo of each light source accompanied by a verbal description, my light reading from an incident light meter of the highlights and shadows, and the f-stop setting on my camera when I took the picture. In most cases, I chose a setting halfway between the two extremes (when the difference was two or fewer f-stops) in order to achieve a properly exposed photograph. In other cases, when the extremes were greater, I chose a setting closer to the highlight meter reading. This ensured that I would get enough detail in the highlights.

Reflectors—Light Source 6 Feet Away

Table 7.1 visually illustrates the difference in the light output and quality of some reflectors that I own and use. Standard reflectors typically come with flash heads when you purchase them.

tip

Don't forget that the bare flash tube is an excellent light source on its own without any attachments. I often use a bare flash bulb to mimic sunlight when shooting in my studio. After all, the sun doesn't use any reflectors, umbrellas, or soft boxes.

note

Be aware that manufacturers do offer reflectors that are other sizes. They have different reflective surfaces and various lighting characteristics. Try them out and see how the quality of the light varies.

	Photos	Description	Incident Meter Reading: Highlights/Shadows	Camera Setting: f-stop
Table 7.1 Reflector Light Output Table		**5" reflector:** Medium light output, medium shadow, and medium contrast range	2 ⅓ f-stop range	
		Wide shot	f7.1/f3.2	f4.5
		Close up	f7.1/f3.2	f4.5
		9" reflector: High light output, sharp shadow, and high contrast range	2 ⅔ f-stop range	
		Wide shot	f14/f5.6	f10
		Close up	f14/f5.6	f10

	Photos	Description	Incident Meter Reading: Highlights/Shadows	Camera Setting: f-stop
		10" reflector: Medium light output, medium shadow, and medium contrast range	2 ⅓ f-stop range	
		Wide shot	f11/f5	f7.1
		Close up	f11/f5	f7.1
		22" reflector: Low light output, soft shadow, and low contrast range	1 f-stop range	
		Wide shot	f7.1/f5	f5.6
		Close up	f7.1/f5	f5.6

Table 7.1 Reflector Light Output Table *(continued)*

Umbrellas—Light Source 6 Feet Away

Umbrellas are very portable and useful lighting tools to have on location and in the studio. They are also very economical. Because of their round shape, umbrellas reflect a circle of light onto the subject. This is visible as white spots or highlights. The size of the umbrella and its distance from the subject affect the size of the reflection. The color of the umbrella's surface material—silver, white, zebra (silver and white), gold, or what have you—affects the detail and sharpness of shadows and the overall color cast of the photograph. Table 7.2 illustrates the effect of using various umbrellas.

With the 33-inch umbrella with silver interior and black exterior, the difference in proper exposure between the highlights and shadows is three f-stops. These photographs have a lot of contrast and less detail in the shadows. The silver surface is highly efficient at reflecting light, and shows more texture than a white surface. It provides a brighter light. In food terms, I would call it "zesty." With the 40-inch umbrella with white interior and black exterior, the difference between the highlights and shadows is one and two-thirds f-stops. The resulting photographs have a lighter shadow with softer edges. As you can see with the 40-inch white shoot-through umbrella, the difference between the highlight and the shadow is two f-stops. I set my camera for the f-stop halfway between the two settings to get a photo with detail in both the highlights and the shadows. The 60-inch zebra umbrella uses a similar contrast range and exposure to the 40-inch white umbrella; the main difference is the size of the highlight. The combination of silver and white surfaces provides a good balance of reflection, texture, and softness in the shadows.

	Photos	Description	Incident Meter Reading: Highlights/Shadows	Camera Setting: f-stop
Table 7.2 Umbrella Light Output Table		**33" umbrella with silver interior and black exterior:** Highlight output, sharp shadow, and high contrast range	3 f-stop range	
		Wide shot	f8/f2.8	f5.6
		Close up	f8/f2.8	f5.6
		40" umbrella with white interior and black exterior: Medium light output, soft shadow, and low contrast range	$1\frac{2}{3}$ f-stop range	
		Wide shot	f8/f4	f5.6
		Close up	f8/f4	f5.6

Photos	Description	Incident Meter Reading: Highlights/Shadows	Camera Setting: f-stop
	White 40" shoot-through umbrella: High light output, medium shadow, and medium contrast range	2 f-stop range	
	Wide shot	f8/f4	f5.6
	Close up	f8/f4	f5.6
	Zebra (silver and white) 60" umbrella: Medium light output, soft shadow, and low contrast range	1⅔ f-stop range	
	Wide shot	f5.6/f3.2	f4.5
	Close up	f5.6/f3.2	f4.5

Table 7.2 Umbrella Light Output Table *(continued)*

Soft Box—Light Source 6 Feet Away

A soft box is another diffusion lighting tool that creates the quality of light similar to the light that shines through a north-facing window. It has a good f-stop range for capturing detail in the highlights and in the shadows of an image. The soft box (or bank light) is portable and breaks down easily for use on location. It is more expensive and is not as time-efficient in setting up as an umbrella. Most soft boxes have internal diffusion materials that help soften the light even further to distribute light evenly over the entire set. Various soft boxes have interchangeable panels for the interior reflective surfaces. The exterior shape of the soft box varies as well, and there are many sizes available to purchase. This influences the size and shape of the reflections that are visible on shiny objects in the food photograph. Table 7.3 illustrates the effect of using a 22×30-inch soft box from various positions.

tip

In general, I prefer to use a 2×3-foot soft box with a silver interior and an internal diffuser when I photograph food, and a white shoot-through umbrella when I photograph people. The catch lights are different shapes, and the quality of the light varies. How I want the shot to look will determine what type of lighting I ultimately use.

	Photos	Description	Incident Meter Reading: Highlights/Shadows	Camera Setting: f-stop
Table 7.3 Soft Box Light Output Table		**22×30" soft box:** Medium light output, soft shadow, and medium contrast range	2 f-stop range	
		Wide shot	f5.6/f2.8	f4
		Close up	f5.6/f2.8	f4
		Wide shot with soft box angled down	f6.3/f2.8	f4.5
		Wide shot with soft box at a straight angle	f5.6/f2.8	f4.5

Soft Box with Grid Spot Backlight—Light Source 4 Feet Away

In Table 7.4, I kept both my camera settings and my main light source (a soft box) constant. The only variation involved the power setting to the grid spot that I used as a backlight.

Table 7.4 Soft Box/Grid Spot Light Output Table

Photos	Description	Main/Grid Spot	Camera Setting: f-stop
	Lighting setup	f6.3/Not used	f5.6
	Wide shot without grid spot	f6.3/Not used	f5.6
	Wide shot with grid spot, small highlight	f6.3/f8 ($^2/_3$ f-stop range)	f5.6
	Wide shot with grid spot, medium highlight	f6.3/f16 ($2\,^2/_3$ f-stop range)	f5.6
	Wide shot with grid spot, large bright highlight	f6.3/f32 ($4^2/_3$ f-stop range)	f5.6

Soft Box with Grid Spot Backlight and Mirrors—Light Source 4 Feet Away

Table 7.5 illustrates the use of a grid spot backlight and mirrors. The results show that by adding mirrors, you add specular highlights. Depending on the angle, distance, and shape of the mirrors, the catch light will vary on the subject. This is the professional way to achieve detail and highlights that make my food photographs stand out.

Table 7.5 Soft Box /Grid Spot/Mirrors Light Output

Photos	Description	Main/Grid Spot	Camera Setting: f-stop
	Lighting setup: Soft box only	f5.0/Not used	f3.5
	Fruit shot: Wide shot, no highlights in shadow	f5.0/Not used	f3.5
	Lighting setup: 32×40" white board	f5.0/Not used	f3.5
	Fruit shot: Wide shot, large soft milky white reflection in shadow	f5.0/Not used	f3.5

	Photos	Description	Main/Grid Spot	Camera Setting: f-stop
Table 7.5 Soft Box /Grid Spot/Mirrors Light Output *(continued)*		**Lighting setup:** 32×40" white board	f5.0/f5.6 (²⁄₃ f-stop range)	f5
		Fruit shot: Wide shot, specular highlight toward back	f5.0/f5.6 (¹⁄₃ f-stop range)	f5
		Lighting setup: 32×40" white board, one mirror	f8/f8 (no f-stop range)	f7.1
		Fruit shot: Wide shot, specular highlight toward back, new highlight on right front	f8/f8 (no f-stop range)	f7.1
		Lighting setup: 32×40" white board, two mirrors	f8/f8 (no f-stop range)	f7.1
		Fruit shot: Wide shot, additional highlight on toward left back	f8/f8 (no f-stop range)	f7.1

225

Photos	Description	Main/Grid Spot	Camera Setting: f-stop
	Lighting setup: 32×40" white board, three mirrors, overhead shot	f8/f8 (no f-stop range)	f7.1
	Lighting setup: 32×40" white board, three mirrors, overhead shot	f8/f8 (no f-stop range)	f7.1
	Fruit shot: Wide shot, additional highlight on left toward front	f8/f8 (no f-stop range)	f7.1

Table 7.5 Soft Box /Grid Spot/Mirrors Light Output (continued)

Soft Box from Different Angles

In Table 7.6, I moved the soft box and showed you how the highlights, shadows, and background change. The last photograph in Table 7.6 used direct flash, which yields no depth. Not surprisingly, it's the worst photo of the bunch.

Photos	Description	Main	Camera Setting: f-stop
	Lighting setup: Soft box from above at a level angle	f16	f11
	Fruit shot: Wide shot	f16	f11
	Lighting setup: Soft box from above tilted at a forward angle	f14	f10
	Fruit shot: Wide shot	f14	f10

Table 7.6 Soft Box Light Output

	Photos	Description	Main	Camera Setting: f-stop
Table 7.6 Soft Box Light Output *(continued)*		**Lighting setup:** Soft box from the right	f11	f8
		Fruit shot: Wide shot	f11	f8
		Lighting setup: Soft box aimed directly at the subject	f16	f16
		Fruit shot: Wide shot	f16	f16

CHAPTER 8

The Digital Spice: Retouching

Almost every image that is used for reproduction requires some correction, enhancement, and digital processing. The goal is to make the food look great in the photo. That's what makes everyone happy.

There is a real art to retouching food photographs. The key to good digital retouching is training your eye so that you know what (and what not) to retouch. When you first look at the image, ask yourself the following:

❖ What grabs the viewer's attention?

❖ What is your overall feeling about the image, and how does it represent the client's vision?

❖ What will the photograph be used for?

Your first instincts are usually the best.

In evaluating an image, you also want to consider factors such as the following:

- ❖ Is anything in the photograph distracting?
- ❖ Is the color of the food accurate?
- ❖ Do the colors of props or backgrounds need to be changed?
- ❖ Should the color cast of the photograph be adjusted to alter the mood?
- ❖ Are there fingerprints or crumbs on the dish that need to be removed?
- ❖ Are there blemishes or bruises on fruit or vegetables that need to be fixed?
- ❖ Should the label on the wine bottle be blurred? Is it straight?
- ❖ Should the fish be cooked more, or be whiter?
- ❖ Is the meat cooked enough, or does it look too rare?

In every retouching session, the process is to evaluate the image on a macro level to determine the major issues and resolve the big problems first. Then, we go deeper into the image and make fine adjustments to achieve the desired final look.

Before **After**

In addition to addressing image problems, digital retouching also corrects or adjusts for technical issues. Digital camera sensors and firmware (software) vary from one manufacturer to another and have different biases and defaults. Pictures taken on different cameras can also vary in file size and resolution, and you may need to adjust for these factors depending on how the final image will be used.

Adobe Photoshop

As a digital editing tool, Adobe Photoshop is the most widely used. It is the accepted industry standard for graphics professionals, much as Microsoft Word and Microsoft Excel are the standard for business word-processing and spreadsheet applications. Using Photoshop, you can perform all the traditional retouching techniques that have been used for decades, as well as use an amazing array of digital image-enhancement and manipulation tools. At the time of this writing, Adobe has just released Photoshop CS2, and I've had the pleasure of trying it out. I'm particularly fond of the new Smart Sharpen tool, because it helps cure what I call the "halo effect" you get when you over-sharpen using other Photoshop methods. Unfortunately, Photoshop is so full of tools that a detailed discussion of the program is beyond the scope of this book (although I do take you through some retouching steps later in this chapter). Consider picking up some of the books written specifically about Photoshop CS2 if you want to know more. I highly recommend David Busch's *Adobe Photoshop CS2: Photographers' Guide*, published by Thomson.

note

How you use certain Photoshop features for food photography varies somewhat from how the program might be applied to portrait and fashion. Using Photoshop and its tools is a continual learning process; the tutorials and the instructional CD that are packaged with the program are very helpful. Also, try to attend any Photoshop workshops offered in your area.

Setting Up the Digital Workstation

Using Photoshop for food photography requires a powerful computer setup. While this involves a substantial original investment, you'll enjoy a significant payback—primarily by eliminating film and processing costs, and by reducing the amount of time spent in retouching. In particular, you need a calibrated workstation to view and process your images correctly. In fact, a busy studio may need multiple workstations to retouch, print, and archive finished pictures on CDs, DVDs, and external hard drives.

note

Until recently, archiving digital images on CDs was the preferred method of storage. Now, DVDs—which store anywhere from 4.7 to 17 gigabytes (GB) of information depending on the type of disk—are becoming more popular because they can store as much as 25 times more data than CDs. In addition, DVDs provide more data protection than CDs because the reflective coating is sandwiched between two polycarbonate layers, which protect the media from scratches. DVDs are also faster than CDs for data access.

Professionals should have redundant systems (RAID) to archive their images. RAID (Redundant Array of Independent Disks) is a group of storage devices and disk drives—such as magnetic tape, hard drives, and optical drives—that operate as a single unit. This technology provides a high level of data security because if one of the storage units in a group fails, data can be transferred to other units in the system. How elaborate your computer setup is depends on the quantity of pictures you take and the file sizes.

tip

Do not leave your CDs and DVDs in bright light or warm environments. They might warp, which can cause errors in data transfer. Because these disks are optical storage devices, bright light can cause damage, which affects the data.

The type of computer equipment you buy will depend largely on your budget. Regardless of budget, however, you'll need the following:

❖ A Macintosh or PC.

❖ 100–500GB of hard-drive space to install all applications. Installing Photoshop CS2's common files alone consumes at least 1GB on the primary hard disk.

❖ A DVD/CD-ROM drive. Make sure to check the data buffer and the write times. Faster is better!

❖ A high-speed Internet connection is a must!

❖ A large monitor with a high-end video card. Remember, your monitor is how you and your client will view your photos, so buy the best one you can afford.

❖ A Wacom tablet for ease and freedom in retouching.

tip

When setting up your work area, make it a point to keep wires coiled and behind the desktop, and to keep metal objects away from the monitor. (If metal objects are placed near the screen, the magnetic field around the monitor will be affected, and this can cause a color shift in certain parts of the screen.)

System Requirements: Low Budget

If your budget is low, limit your computer-related purchases to the following:

❖ A Macintosh or PC with 1GB RAM, one large internal hard drive, and an above-average CPU

❖ A CD/DVD backup system

❖ A 17-inch color monitor

❖ A high-end video card

❖ Adobe Photoshop image-editing software

❖ Color-calibration tools for hardware and software

❖ A photo-quality printer

tip

If you can swing it, upgrade to 2GB RAM. Your high-res photos will open more quickly.

System Requirements: Medium Budget

If you have a medium-sized budget, you can upgrade your computer-related purchases as follows:

❖ A Macintosh or PC with 2GB RAM, two large internal hard drives (one for program files and one for working data), and a high-speed CPU

❖ One external hard drive and CD/DVD backup system

❖ Off-site storage for your CD/DVD image library

❖ A 22-inch monitor

❖ A higher-end video card

❖ Adobe Photoshop image-editing software

❖ Color-calibration tools for hardware and software

❖ A high-end, long lasting, photo-quality printer with high DPI/PPI, a fast print speed, color matching, and profiling

System Requirements: High Budget

If you have a big budget, the sky is the limit. Look into purchasing the following:

❖ A Macintosh or PC with 4GB RAM, four very large internal hard drives (one for program files, one for working data, and two for mirror data backup), and a cutting-edge CPU

❖ A RAID backup system

❖ Off-site storage with temperature control for your CD/DVD image library

❖ Two large monitors

tip

When using Photoshop, display the tools in one monitor and a full screen of the image you're working on in the other monitor.

❖ A highest-end video card

❖ Adobe Creative Suite image-editing software

❖ Highest-end color-calibration tools for hardware and software

❖ A cutting-edge, long lasting, photo-quality printer with the highest DPI/PPI, fastest print speed, color matching, profiling, and large paper capabilities

note

Avoid eating and drinking near your computer. Accidents do happen!

Calibrating Your Monitor

WYSIWYG (What You See Is What You Get) is not always the case with digital image files. That's because all computer monitors, like color TVs, have different color profiles. Basically, they represent the same colors differently. Nowhere is this more evident than when you walk into a home electronics store and see a wall of TVs on the same channel; they all appear different, with certain sets adjusted improperly. Compounding the problem is the fact that there are various types of monitors available—regular CRT monitors, laptop monitors, LCD monitors, and so on—and viewing angle varies among them.

Your computer monitor is your window to what the final image will look like. You must be able to trust what you see on the screen. The only way to do this is to obtain a calibration device that assesses accurately, and software that creates a profile that renders proper color. Calibration should be achieved with a colorimeter, or spyder, as they're called, not by your eye. These instruments perform a mathematical assessment of the monitor color output for true accuracy. There are many calibration software packages and devices available.

tip

It is important to calibrate monitors frequently—at least once a month. They do have a tendency to shift colors and brightness levels.

Organizing Your Data

There are many methods for organizing digital images, but this one has worked for me since 1995:

1. While shooting, view images on a monitor and make a preliminary selection with the client.

2. Download the original images from the camera into a folder on your hard drive.

3. Rename the folder with the date in this format: **year, month, day_client name_job**. For example, a job for Barilla on September 16, 2005 would be labeled **050916_Barilla_DinnerParty**. This will keep all your job folders in chronological order on your hard drive.

4. Within that folder, create a subfolder named **Originals**, make sure that all of the original files from your camera are placed in that folder, and always keep them there untouched.

5. Create three new subfolders and label them **Selections**, **PRINT_300dpi**, and **WEB_72dpi**.

6. Copy the selections that you made with your client from the **Originals** folder (leaving the **Originals** folder intact) and paste them into your **Selections** folder. You should now have a copy of each selected image in both the **Originals** folder and the **Selections** folder.

7. Retouch the selected files in Photoshop. When you are finished, save the final, retouched image in the **PRINT_300dpi** folder at 300dpi as a TIFF file, at the full image size it was captured.

8. Resize that final print version for use on the Web to 72 dpi, sharpen it a little, and save it as a JPEG with image quality set at 9 (I found this to be a good setting to use) in the **WEB_72dpi** folder.

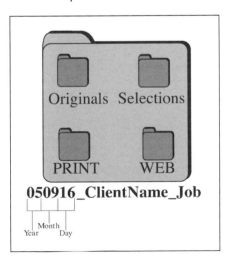

The Art of Retouching Food: Using Adobe Photoshop

Retouching food is truly an art. In this section, you'll learn how to use Photoshop to do just that. Before you begin, however, let's quickly go over navigating Photoshop, altering some key Photoshop settings, and understanding layers, which is essential.

Navigating Photoshop

Before you dive into using Photoshop to retouch the image, take a moment to familiarize yourself with the layout of the program. In particular, note the location of the following:

❖ The menu bar

❖ The tool option bar

❖ The toolbar

❖ Palettes

Adjusting Your Adobe Photoshop Settings

Once you have the lay of the land, take a moment to adjust some of Photoshop's default settings for maximum efficiency:

❖ **Color settings.** From the menu bar, open the Edit menu (PC) or (Mac) and select Color Settings to open the Color Settings dialog box. The first time you open this dialog box, the Web Graphics Defaults option will be chosen in the Settings drop-down list. Change this to U.S. Prepress Defaults to change the workspace from sRGB to Adobe RGB 1998, which offers a larger color range.

❖ **Memory and image cache.** From the menu bar, open the Edit menu (PC) or the Photoshop menu (Mac), choose Preferences, and select Memory & Image Cache. In the Memory Usage dialog box, the default is 50 percent. Change this setting to 70 percent so that more RAM is allocated to the program.

❖ **Plug-ins and scratch disk.** Still in the Preferences dialog box, under Plug Ins and Scratch Disk, select your computer's secondary drive (assuming you have one, and I highly recommend that you do) in lieu of the default setting, Startup.

❖ **Eyedropper.** Go to the Eyedropper icon in the toolbar, where you will see sample sizes on the menu bar. Change the default from Point Sample to 3x3 Average. This will give you a better indication of what the value of a particular area is.

❖ **White Point Eyedropper.** If you use the default RGB values of 255 for the White Point Eyedropper, you wind up with pure white or "paper white," which cannot be reproduced on a printer. To set the white to a point that is reproducible by ink, double-click the White Point Eyedropper (the right Eyedropper icon in the Levels window; it has a clear tip). Change the R, G, and B levels from the default, 255, to 244, and click OK. Photoshop will ask you to save the new defaults after you use levels.

❖ **Black Point Eyedropper.** If you use the default RGB values of 0 for the Black Point Eyedropper, you get "pure black" with no detail at all. To set the black point such that shadows appear with detail and not simply as pure black blobs, double-click the Black Point Eyedropper (the left Eyedropper icon in the Levels window; it has a black tip). Change the R, G, and B levels from the default, 0, to 10, and click OK. Photoshop will ask you to save the new defaults after you use levels.

Understanding Layers

The key to maintaining control of your image is to ensure that you correct one problem at a time using layers. A layer is like an acetate sheet placed over the image, on which corrections are made and effects are added. You can stack multiple layers on top of each other, with each layer containing no more than a few small adjustments. By using layers, you keep the original image intact. Moreover, each layer can be altered or deleted without affecting the other layers.

There are several different kinds of layers:

- ❖ **The background layer.** This contains the original image.

- ❖ **Adjustment layers.** These include levels, curves, and hue/saturation. You create an adjustment layer by clicking the New Adjustment Layer button, which resembles a half-moon, at the bottom of the window.

- ❖ **Type layers.** These can be used to add text to your image.

- ❖ **Pixel layers.** These enable you to duplicate or move elements contained in the original background image or to superimpose elements from other images.

Retouching the Image

The retouching process varies depending on the photograph. Simply put, you must open the image in Photoshop and assess it to determine what Photoshop tools you must use to improve it. As you assess the image, determine whether there is a color cast. Use the Eyedropper and the Info window to examine various parts of the image. Is the image too light or dark? If so, you'll need to correct exposure. If the image looks a bit flat, then you'll want to tweak the contrast. Is the image vibrant? If not, determine whether you want to saturate any particular colors. After global corrections have been applied to the image, you can reassess the image for detail corrections.

In this section, using the photo shown opposite, we'll address the following picture elements:

❖ Beans

❖ Fish

❖ Skin

❖ Fruit

In particular, we'll make the following global corrections:

❖ Crop and straighten the image if needed.

❖ Set the image size to a working resolution of 300dpi.

❖ Address the overall color cast with levels in adjustment layers.

❖ Use curves to adjust contrast and exposure in adjustment layers.

❖ Adjust color saturation to add vibrancy in adjustment layers.

In addition, you'll correct fine details through the use of layers and masks. This involves the following:

❖ Lightening and darkening certain areas of the image with burning and dodging.

❖ Removing spots and blemishes with cloning and healing brushes.

❖ Sharpening the image using channels.

Finally, you'll save the master file with all its layers intact as a Photoshop document (PSD format), and then duplicate and flatten the image in different formats for various uses.

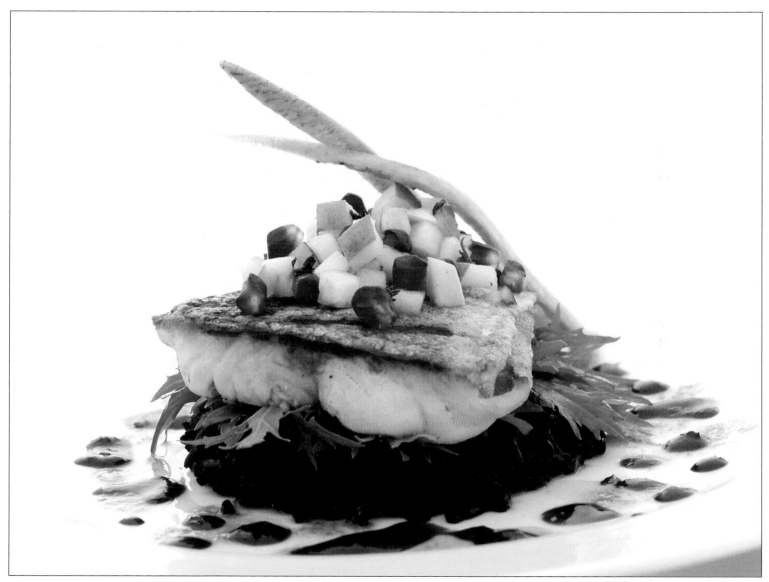

Original Unretouched Image

Cropping and Straightening the Image

Sometimes, an image is taken off-level, and you'll need to straighten it. Conversely, you might want to change the horizon to create an angled or off-level effect. To set the level of the image, you use the Measure tool, which is nested underneath the Eyedropper.

note

Although you don't need to know them at first, all these tools have keyboard shortcuts, which allow you to move directly to a command or function without using the mouse. Usually, you activate the shortcut by typing the first letter of the tool's name. I will indicate commonly used shortcuts in parentheses after a command. To get to a nested tool, hold down the Shift key while pressing the shortcut key (for example, Shift+I).

1. Click and hold on the Eyedropper tool to open the nested tools below.

2. Select the Measure tool (press Shift+I repeatedly until you reach the Measure tool).

3. Drag a line across the image to set the desired horizon.

4. Press Spacebar+Ctrl (PC) or Spacebar+Command (Mac) to zoom into the endpoints of the line drawn by the Measure tool in order to place them exactly.

5. From the menu bar, open the Image menu, choose Rotate Canvas, and select Arbitrary.

6. Click OK. The horizon will be set automatically.

When the image is level, you can crop it.

1. Select the Crop tool (C).

2. Drag the tool across the image to create a bounding box with "handles" at each of the four corners and in the center of each side.

3. Click and drag a handle to move it to the desired location.

4. When you have set the desired boundary, double-click inside the bounding box to crop the image.

Setting the Image Size to a Working Resolution

The next step is to change the image size in order to establish a "working resolution"—that is, to convert the image to a standard 300dpi working size.

1. Open the Image menu and choose Image Size.

2. In the Image Size dialog box, uncheck the Resample check box.

3. Change the Resolution setting to 300 pixels/inch and click OK.

If you uncheck the Resample check box, the picture is not changed, but it is expressed in the way the photographer finds it convenient. 300ppi is a good convention. If the Resample check box is checked, then you are actually changing the image size either up or down. When changing the image size upward, use the Bicubic Smoother setting. When changing the image size downward, use Bicubic Sharper.

Addressing the Overall Color Cast with Levels

To fix the color cast of your image using levels, do the following:

1. In the Layers palette, click on the New Adjustment Layer button (located at the bottom of the palette) and choose Levels.

2. While pressing the Alt key (PC) or Option key (Mac) on your keyboard, click and drag the White slider to the left until the first part of the image begins to turn white.

3. Drag the slider back to its original position and zoom in to at least 100 percent of the image size.

4. Place a color sampler by pressing the Shift key as you click on the spot where the image began to turn white.

5. Select the White Point Eyedropper and click inside the color sampler. This sets the image's white point to 244.

tip

By doing this, you neutralize the RGB values (as you can see on the info palette), and automatically have an accurate color rendition in your photograph. Then again, you might want some color shift in your photograph. Indeed, most images have some form of color contamination. Understanding how to neutralize a white point is a basic concept. If, after neutralizing, you feel you need a bit of warmth back in the image, you can control how you want to add it back without having it look like it is a color cast.

6. While pressing the Alt key (PC) or Option key (Mac) on your keyboard, click and drag the Black slider to the right until the first part of your image begins to turn black.

7. Drag the slider back to its original position and zoom in to at least 100 percent of the image size.

8. Place a color sampler by pressing the Shift key as you click on the spot where the image began to turn black.

9. Select the Black Point Eyedropper and click inside the second color sampler. This sets the image's black point to 10.

10. If you perceive a lingering color cast in the midtones, open the Channel drop-down list in the Levels palette and select the channel (Red, Green, or Blue) that needs adjusting.

11. Move the Gamma slider, found in the middle, right or left to correct the cast.

12. Open the Channel drop-down list in the Levels palette and select the RGB composite channel.

13. Move the middle slider to either brighten or darken the midtones if you feel they need adjustment. When you're finished, click OK.

Using Curves to Adjust Contrast and Exposure

To adjust contrast and exposure, do the following:

1. In the Layers palette, click the New Adjustment Layer button and select Curves. The Curves dialog box opens with a graph plotting a straight diagonal line. The horizontal axis represents the original intensity values of the pixels (input levels), and the vertical axis represents the new values (output levels).

2. Place plot points on the intersecting graph line such that their Input and Output settings are 64, 128, and 192. If you misplace a point, simply adjust the Input and/or Output number in the dialog box, and Photoshop will move the point to the correct location.

tip

If you want to adjust only a portion of an image, you can paint with black on a layer mask to block out the parts of the image you want to preserve. More on that in the section "Correcting Fine Details Through the Use of Layers and Layer Masks."

3. To darken an area, move a point downward toward the horizontal axis. To brighten an area, move a point upward. By making the light tones lighter and the dark tones darker, you are creating contrast.

4. To experiment with this, click a point or press Ctrl+Tab (PC) or Command+Tab (Mac) to select a point. Then, using the up and down arrow keys on your keyboard, move the 64 point downward and the 192 point upward to form a gentle S-curve. While moving the points, watch how the image changes; stop when the image's contrast is increased to the desired level. When you are satisfied, click OK.

tip

You can cycle through the plotted points by pressing the Ctrl+Tab (PC) or Command+Tab (Mac) shortcut key.

Adjusting Color Saturation to Add Vibrancy

To adjust color saturation in order to add vibrancy, do the following:

1. In the Layers palette, click the New Adjustment Level button and select Hue/Saturation.

2. In the Edit drop-down list, select Master.

3. Slide the Saturation bar to increase or decrease the saturation for this channel as desired.

4. Repeat steps 2 and 3 for each individual color family (reds, yellows, greens, blues, cyans, and magentas), sliding the Saturation bar to 100 percent so you can see what part of the image is being affected, and then backing off the saturation until the desired amount of saturation is achieved.

5. Click OK.

tip

To achieve finer degrees of adjustment, move the color bar sliders at the bottom of the dialog box.

note

If a color is not present in the image, you cannot saturate it. Colors can be added or changed through the use of the Curves dialog box later on in the process.

Correcting Fine Details Through the Use of Layers and Layer Masks

Now you are ready to make finer, more detailed adjustments to the image using layers and layer masks. *Layer masks* hide or reveal parts of a layer, enabling you to specify whether certain parts of the image should be protected from the changes you make. Use black to hide and white to reveal the area to be corrected. Before you begin, take a moment to evaluate and identify specific areas of the image that need correction or enhancement. Then, in the Layers palette, be certain that the topmost layer is highlighted so that it is the active layer. Each subsequent layer you create will be added on top of the global corrections that you have already made.

1. From the flyout menu, which is the sideways arrow in the top-right portion of the Layers palette, choose New Layer.

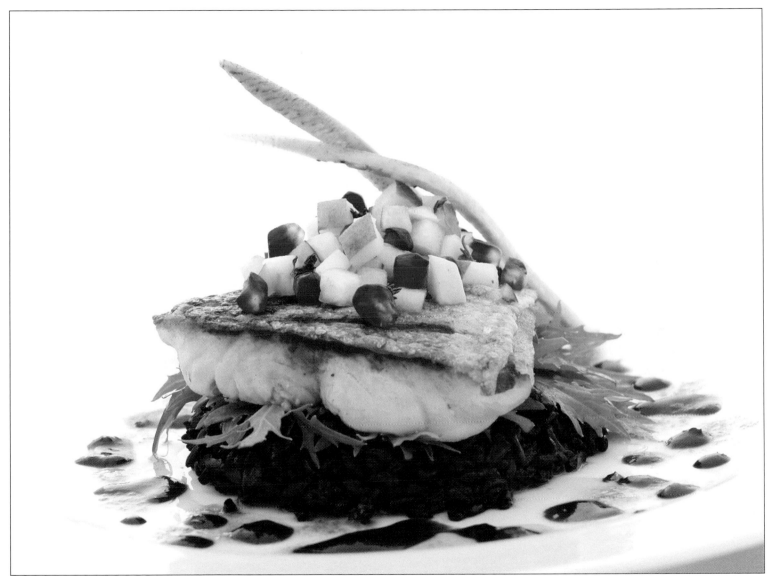

First Stage of Retouching the Image

2. The New Layer dialog box opens. Name the new layer **dodge & burn**.

3. Change the Mode setting from Normal to Soft Light, and check the Fill with Soft-Light-neutral color check box. When you're finished, click OK.

Next, let's use the Brush tool to burn and dodge the image. Burning an area darkens it; dodging an area lightens it selectively.

1. Select the Brush tool.

2. Press the D key on your keyboard to set the foreground/background color box on the toolbar to the default. (Use a soft brush at a low opacity—it's better to brush gently.)

3. Paint the image with black in the foreground to "burn" it by holding down the left mouse button and moving the Brush tool over the image. To "dodge" the image, change the foreground color to white and follow the same procedure.

To remove unwanted spots or blemishes, do the following:

1. In the Layers palette, create a new layer and call it **Spot**.

2. Select the Clone Stamp tool. The Clone Stamp tool takes a sample of an image area, which can be applied over unwanted spots or blemishes.

3. While holding down the Alt key (PC) or the Option key (Mac), click in an area of the image from which you want to sample.

4. Click on unwanted spots until you achieve the desired result.

note

In the Clone Stamp Options box, make sure Sample All Layers is checked. This is in the Tool Options bar, under the main menu at the top.

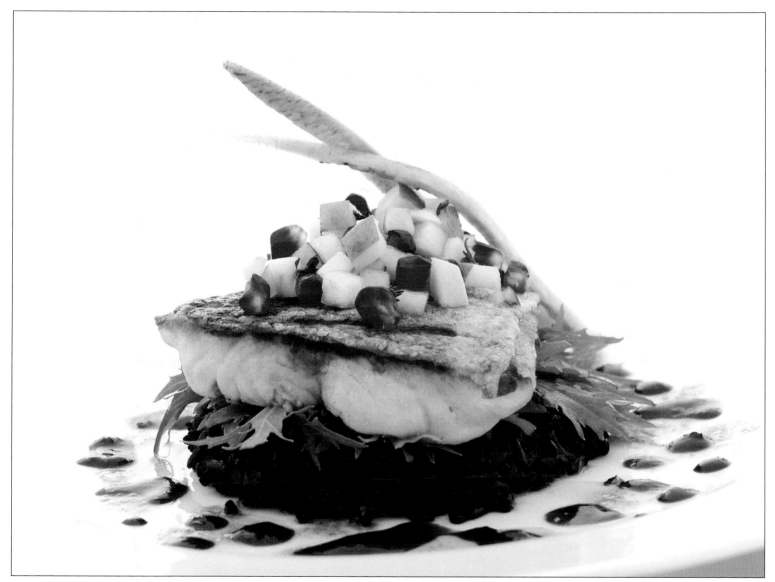

Second Stage of Retouching the Image

The skin on the front right edge of the fish is too light. To rectify this, do the following:

1. Make sure the background layer is selected.

2. Use the Lasso tool to duplicate a portion of the skin that looks as it should, and press the Ctrl+J (PC) or Command+J (Mac) shortcut key to create a new layer consisting of the selected area.

3. Name the new layer **Skin**.

4. Using the Move tool, position the Skin layer on the light skin area.

5. The Patch tool is a good choice to keep the texture of the skin.

6. On the Skin layer, use the Free Transform tool to extend the grill mark.

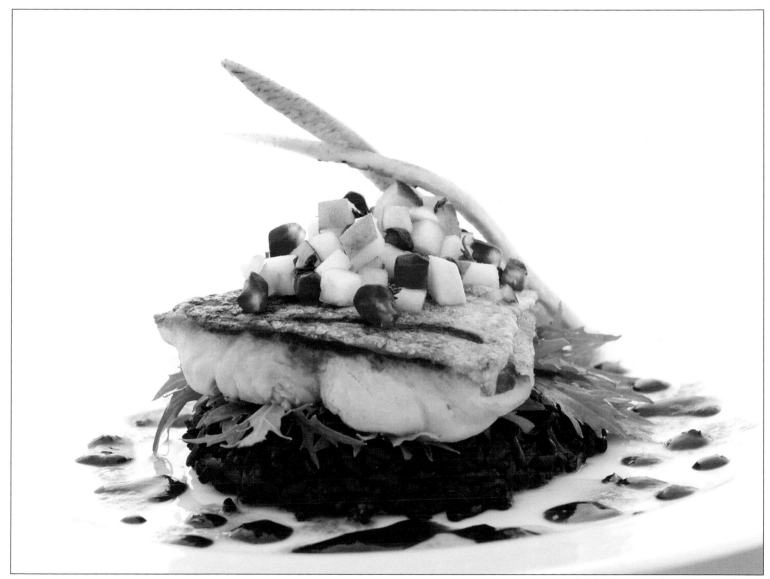

Third Stage of Retouching the Image

I was displeased with the skin tone. To solve the problem, I did the following:

1. Open another curve adjustment layer.

2. Try darkening the skin; you'll notice that the entire image becomes darker. Undo the change.

3. Now invert the mask from white to black and paint the areas that you want to be darker so they will be revealed. Name the layer **darken skin**.

tip

There are always several options in Photoshop. For example, if you have a selection of skin that you want to make darker, you can select Layers in the menu bar and select New Adjustment Layer there instead of in the Layers palette. The advantage of using this approach is that you can opt to confine the effects of the adjustment layer (curves, levels, or what have you) to the one layer immediately under it rather than to all the layers. Then you can darken and adjust just the section of skin in the copy layer. You can even overdo the effect and then add a black layer mask to the fish section layer. The image disappears temporarily but you can paint with white in the mask to reveal it where you want. To change an adjustment layer from a global adjustment to an adjustment that affects only the immediate layer under it, hold down the Alt key (PC) or the Option key (Mac) and click on the line between the adjustment layer and the picture layer. The cursor changes when you have it lined up. Also, a very easy trick without any adjustment layers is to take the section of fish you want to darken and change its mode to Multiply. It makes the picture about 1.5 stops darker and often does the trick. To group a correction with a layer below, simply press Alt+Ctrl+G (PC) or Option+Command+G (Mac).

To sharpen the image, do the following:

1. Click the New Layer button in the Layers palette.

2. Name the new layer **Sharpen**.

3. While holding down the Alt key (PC) or the Option key (Mac), select Merge Visible from the flyout menu which is the sideways arrow in the top-right area of the Layers palette. (You must hold down the Alt/Option key until you see the thumbnail of the image appear in the Sharpen layer.)

4. Click the Channels tab in the Layers palette.

5. Select the red channel.

6. Open the Filter menu, choose Sharpen, and select Smart Sharpen Mask.

7. Generally, the Radius setting should be .8 pixels.

8. Set the Amount to 500 percent and then back off until you achieve the desired sharpening effect.

9. Click OK.

10. Repeat steps 5–9 for the green and blue channels.

note

Do not use the Sharpen tools on the RGB channel. Usually, the blue channel does not need to be sharpened as much as the red and green channels.

Saving the File

The last step is to save the file.

1. Save the master file as PSD with all the layers using the Save As dialog box. Here's a view of our entire job in the layers window. We're almost finished!

2. Save a duplicate image. Flatten the layers in this image and save the file as a TIFF so it can be sent to the printer or client. Rename the file. It can now be resaved in any format and file size needed.

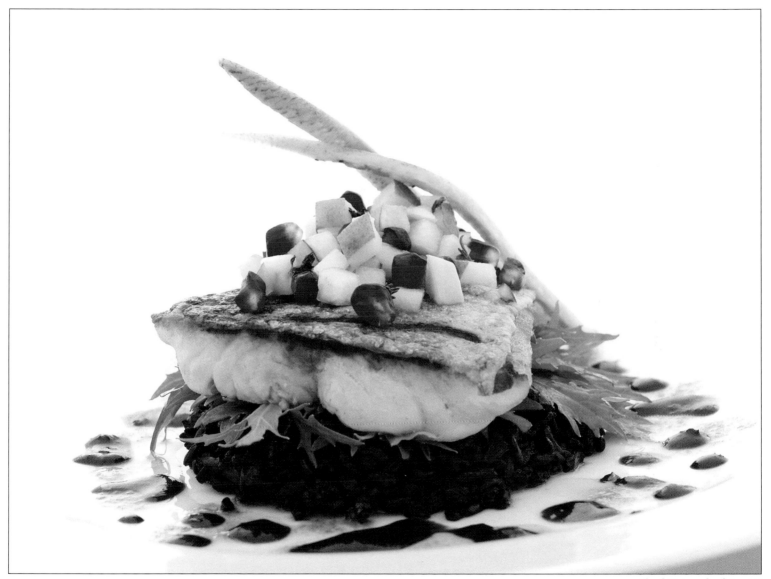

Final Retouched Image

Final Checklist

As you retouch your images, keep the following points in mind:

❖ Try to work on the image at 100 percent or at a screen size that isn't a fraction.

❖ As you select various tools, always check the Options bar for proper settings.

❖ Be aware of what layer is active, and always work on the top one. Keep detail layers on top and global layers on the bottom.

❖ Before painting on a mask, set the foreground/background default colors to black and white.

❖ Feather your selections for better blending.

❖ Save your file frequently as you work—for example, after you add each new layer. This is a good work habit to incorporate into your workflow.

❖ When you save a file the very first time, use the Save As menu command. This preserves your original. After that, use the Save menu command, or press the Ctrl+S (PC) or Command+S (Mac) shortcut key.

❖ Name your layers so you remember what you did on each one.

❖ Never resample your master file. If you need to adjust the file size, create a duplicate. Resample the image in 10 percent increments for the best image quality.

❖ Save your master file with all its layers in PSD format. This allows you to go back and modify any of your hard work later on.

❖ If sharing files with clients, service providers, or friends, it is recommended that you duplicate and flatten your master file and then save it in TIFF format. TIFF is cross platform, which means that whether you're using a Mac or a PC, you'll be able to view your image in TIFF format.

❖ For Internet or e-mail use, save a flattened duplicate file as a JPEG, which is also a cross-platform format. JPEG files are smaller than files of other types, making them quicker to download. I find 9 to be a good image quality setting to use. Also, for the Web, I would change the color space to sRGB.

tip

Mac users: Be certain that your OS adds the file extension (for example, .tiff, .jpg, and so on) to the end of your file names when sharing with other users. You can check for this in the Preferences.

❖ Sometimes, accidents can be fabulous! Don't be afraid to make mistakes or experiment—but do it on a duplicate!

Preparing for Reproduction

Now that you have compiled retouched images, you need to convert them into a useable format for reproduction. You should save your images in the RGB format because most desktop printers work in RGB ColorSpace. Before printing, also be certain to select the proper paper profile. Many manufacturers offer canned profiles as free downloads on their Web sites. When using a paper profile, be sure to turn off your printer's color management. If you are planning to reproduce your work in quantity and/or are seeking better quality than your desktop printer or service bureau can provide, you will need to explore the world of commercial printing. For commercial printing, you should save your images as CMYK; in addition, you need to know the specific settings from the printer.

tip

There are so many variables and challenges in the area of commercial printing that I strongly suggest you contact a full-service printer to obtain the proper settings.(If you have your color space set to US Pre-press, you'll be very close most of the time.)

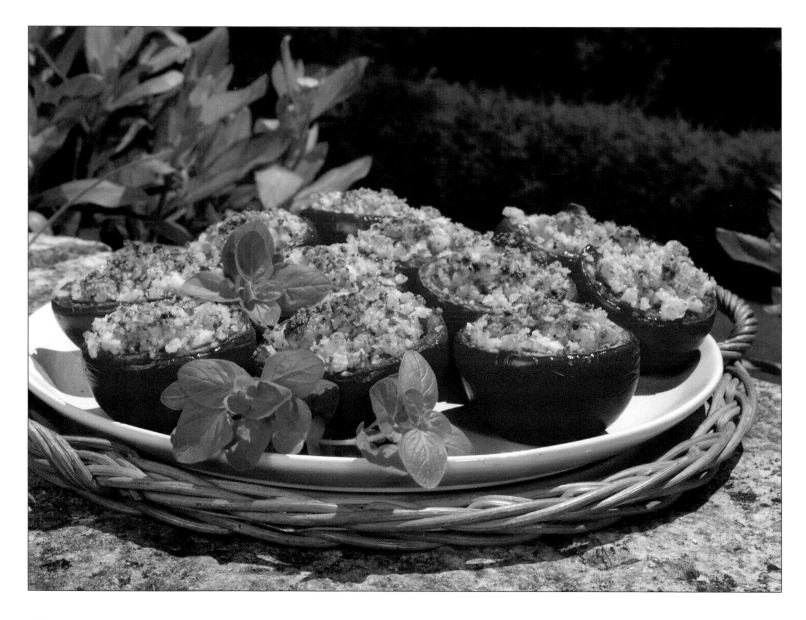

CHAPTER 9

Get Cooking and Make Some Money:
Getting into the Business

Success is about being organized.

Most photographers, including me, are creative individuals. We view the world differently from other people. We prefer to avoid typical, mundane activities like filing tax returns, paying rent, and getting health-insurance coverage. Don't let these tasks overwhelm you. Start with good habits and do them right. This will set you up with a solid foundation that will enable you to maintain a client database and keep your studio running smoothly!

Joan O'Brien, my studio manager since 1991, has taken care of many of those details. She keeps me organized while I run in several directions, talk on my cell phone, and work too many hours of the day and night—multitasking constantly. Because there is only one Joan, I suggest that you use a date book or pocket diary to organize your appointments, maintain your to-do list including calls you need to make, and keep track of your schedule.

Overhead

As my father often reminded me, "Overhead is something that is easy to acquire and very hard to eliminate." Think big, but start small. This is advice I will never forget! With any start-up business, you need to think about how to finance your endeavor. Some people obtain a loan or reach out to find investors. I chose to start out small, using my own savings so I didn't need to worry about repaying debt.

In the beginning of my career as a photojournalist for the *New York Times*, I had minimal overhead. I lived in a house with friends from college. I had a darkroom in the basement and a photo studio in the garage. I used my car as a mobile office, and I had what was, for the time, a state-of-the-art voice paging system to get my assignments and messages.

If you are thinking about getting into the business, before setting up a fully functioning photo studio with a kitchen, use your home. Purchase some inexpensive plates and napkins to use as props. As a digital photographer, you won't need a darkroom, because your computer is your imaging workstation.

Marketing Yourself to Clients and Agents

Often, people suggest writing a business plan. This will help you focus your goals, energy, and passion in a clear, concise manner. You should view this task as a small-business marketing plan that really represents who you are and what you have to offer. It should include your products and services and who your prospective clients are. This will help you define and narrow your target market. Updating it often and revising it as necessary will keep you on track.

Looking for business is not a dress rehearsal. Start with your circle of friends and associates to help generate assignments and business leads. Most of them will be happy to help you, if you ask. Don't be afraid to get out there and network. Meet and greet prospective clients—such as restaurateurs, members of community groups, and members of local photo clubs and associations—every chance you get. You'd be surprised how eager people are to help.

Whatever you do, don't close the discussion without leaving them something in hand. This could be a promotional piece or photo postcard that shows samples of your work and clients. You always want to leave potential clients and people you meet with something to remember you by.

How I Got My Start

I had the good fortune of starting my career at the New York Times, which allowed me to make many contacts with people in the media, advertising, politics, show business, and other industries. When I started there in 1975, I was a general assignment photographer, covering stories mainly on Long Island.

I was the "new kid" on the staff, and lucky for me, I had a car. I got involved in food photography when my editor asked me to drive out to East Hampton a few times a week to shoot pictures that accompanied articles by Craig Claiborne and Pierre Franey in the Living Section. Other photographers didn't want to make the long drive from the city. This led to photographing my first cookbook and many other related opportunities.

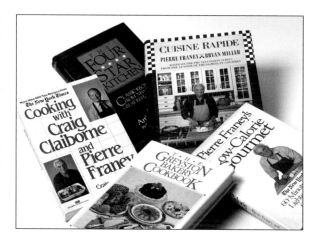

Since then, I've worked with many chefs, and now my photos appear in more than 30 cookbooks. It didn't hurt that my mother is a great cook, and that I love to cook and eat as well. Being able to speak French and Italian also helped me develop good relationships with chefs, restaurant owners, and many other people in the food business; we spoke a common language!

Networking Helped Me Become an Olympus Visionary Photographer

The photo of the Marriott Marquis Broadway Lounge that appears in Chapter 1 was originally shot to promote their recent hotel renovations. Marriott decided to turn it into a billboard in Times Square. When I mentioned to another client how well my Olympus E-10 camera performed, he told me that Olympus was one of his clients. He put Olympus in contact with me. After meeting me and seeing the work I did with their equipment, Olympus honored me as one of 30 Visionary Photographers in the country, emphasizing my accomplishments in food photography.

Your business card is one of the simplest, least-expensive forms of advertising you can do. It makes a definite impression. Remember, you want the people who receive them to have a lasting positive image of you—you only have one chance to make a first impression! If you are not certain about what effectively communicates your skill, consult a graphic designer. Ask friends if they know of any. You'd be surprised how little this costs compared to how much return on investment you'll receive. I cannot stress how important this step is in setting up your business.

Postcards featuring some of your best work are also great for sending announcements, greetings, and reminders to clients. In addition, a monthly e-mail postcard is an effective way to keep in touch with clients and prospective customers.

tip

I have always found that putting a great, colorful, visual image on my card makes it stand out and helps people remember me—as well as identify me as a food photographer.

In addition, there are a number of other simple advertising and self-promotion vehicles that almost any photographer can use. My Web site has proven to be one of the most lucrative investments I have ever made. This online portfolio has exposed my work to potential clients around the world.

I approached the design of my Web site the same way as my photography—simple and clean. There are many desktop-publishing tools, such as Microsoft Publisher, that enable you to create your own sites. Many Internet service providers offer these tools as well. But, there is nothing like a great designer to help you improve your image. My designer, Eric Steinhilber, helped me create a user-friendly and eye-catching layout that really meets my needs.

Finally, don't miss any opportunities to promote yourself and your work in local newspapers and trade publications. You can write articles about your work and technique for photography newsletters and magazines. Don't forget to ask for reprints, which can be sent out as promotional pieces.

In fact, the publisher of this book contacted me as a result of articles about my work in photography magazines, and one that I had written for Digital Imaging magazine. I also give seminars, workshops, and lectures about digital food photography in various venues.

tip

Major professional societies offer sources of ideas for successful self-promotion. For instance, the ASMP has a series of articles written by photographers in its member publication, ASMP Bulletin, and also on its Web site (www.asmp.org).

In addition, there are many listing services, such as Find a Photographer, and online forums where photographers can ask questions and receive answers. Two of the most useful, APAnet and APAdigital, are sponsored by the Advertising Photographers of America (APA) and hosted by Yahoo. Another online forum, specifically for emerging professionals and also hosted by Yahoo, is ASMPproAdvice (http://groups.yahoo.com/group/ASMPproAdvice). To sign up, visit groups.yahoo.com and use the search function.

Representatives and agents provide marketing services and contacts for professional photographers. They promote photographers by circulating portfolios to advertising agencies and marketing firms, and handle a wide range of negotiating, billing, and professional services. Typically, agents charge commissions of 25 percent of the photographer's total fees. Although they tend to represent established professionals, they also are on the lookout for new talent.

It takes time and hard work to build up a client base. Remember that fair business practices, meeting deadlines, understanding client needs, and going "above and beyond" the call of duty are vital in maintaining good relationships. One happy client will lead to more; for many years my business has been based almost entirely on referrals.

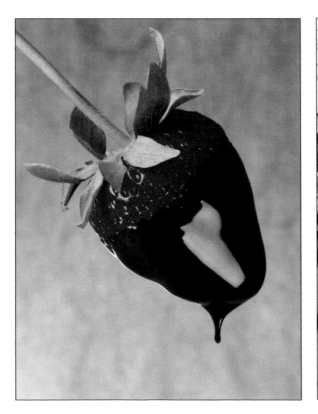

Stock Photography

Stock photography—shooting a multitude of generic images, cataloguing your photographs, and making them available for quick retrieval—is a business opportunity you can explore. Let's face it, everyone is in a rush. Instead of setting up a photo shoot, it can sometimes work for a client to purchase an existing image available from a stock agent or on the Web.

Until several years ago, some photographers shot almost exclusively for stock. There were a number of independent agencies licensed photographs. Recently, however, there has been a lot of consolidation in the industry and only a few agencies remain—limiting the number of opportunities available to photographers. Today, some photographers license images directly through their own Web sites.

Food photographers can supplement their income by licensing photos and making them available through stock agents, but don't count on doing this as a livelihood. Also, be careful to protect the rights you have to your own work before making it available as stock photography. Always obtain appropriate property and model releases so you won't encounter legal hassles down the road. The price charged for stock photos is negotiable, depending on how the image will be used. There are many different levels of usage, such as royalty-free and rights-managed use. Be sure to do your research before signing any contracts.

Creative Team

Producing high-end digital food photography at the professional level is a team effort. Chefs, food stylists, prop stylists, and assistants are all a part of the team. Establishing good relationships with these professionals and associates is fundamental to furthering your career. I have been working for The French Culinary Institute for more than 20 years. I've met many chefs and other notable industry professionals there. It has been a great networking source.

Here's some of the esteemed faculty, associates and graduates of The French Culinary Institute. The French Culinary Institute (The FCI) has been rated one of the top 10 culinary schools in the United States and Canada.

The Internet is a valuable resource for identifying and contacting stylists and other prospective team members. For example, you can offer your services to shoot for their portfolios while they do the styling, and you both have pictures to show potential clients. What's more, you've extended your circle of contacts, and you have added more people to your "sales force." It's a win-win situation!

tip

Sites like www.craigslist.org are very useful for reaching other creative individuals.

Database and Image Storage

Keeping an accurate and a current database is important for handling the business side of things, and there are many computer programs to help you accomplish this. Research and see what fits your business best.

A little black pocket address book was all I started with 30 years ago. I still have it, because I don't throw anything out. It has survived computers crashing, viruses (human and electronic), and blackouts. I learned a long time ago that if something works for you and does what you need, don't change it.

Although I now use an electronic organizer—a PalmOne Treo with color for my client database, cellphone, and my schedule—there is a lot to be said for paper backup. In the studio, I use Studio Manager software for my client database, billing, and check payments. This software is installed on a separate computer that I use just for the business end of photography. I keep that computer off the Internet to keep it safe from viruses, hacking, and identity theft.

Storing and organizing the photos that I've shot is a large task, since I shoot so much volume. I keep image files on computers with lots of RAM, multiple hard drives, and DVD and CD burners. I always make sure to create a double set of backups and keep them in different locations. I use manila file folders in metal file cabinets for storing older film and prints in chronological order by client name. It costs a lot to keep all of those files in a self-storage facility, but when a client calls for a print from twenty years ago, I can easily find the transparencies, negatives, print order forms, and other paperwork related to the job. It is simple, just space consuming!

For my digital work, I have spindles of CDs and small file drawers with DVDs in chronological order. I keep a second set of DVDs as a backup at a local self-storage facility. I've been archiving jobs for the past three years on DVDs because they hold about seven times as much information as a CD. Dave, one of my interns, has made a catalog of jobs on each DVD in chronological order. This was a tedious task—one that should be started right from the beginning and kept up constantly.

tip

Make sure to use a Solvent-free marker when writing on CDs or DVDs for archival purposes.

tip

It is of the utmost importance that you back up everything and run virus scans on all of your computers daily. Defragment your hard drives once a week.

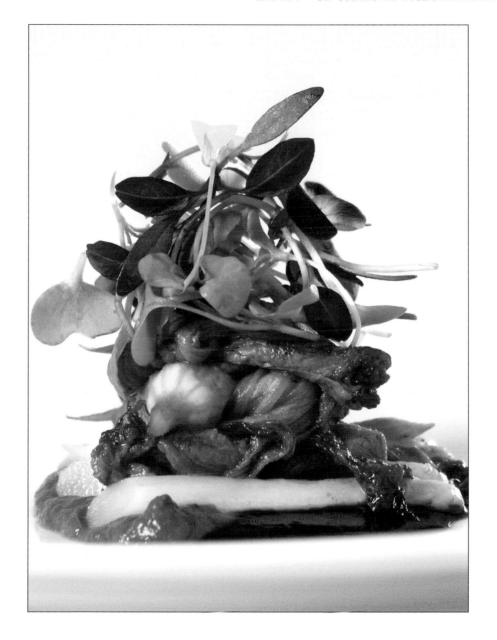

Financial Matters

If you are getting into digital food photography as a business, then you have to get paid. Although it can be a delicate matter, budgets should be discussed right up front. As I discussed in Chapter 3, "Who's Digesting It: Public Relations, Advertising, and Packaging," budgets will vary depending on the final usage of the photo and on the people and resources needed to produce it.

You need to protect yourself financially by ensuring that clients approve assignments before they begin. I always present the pricing and receive approval from the client before I proceed. As a general rule, I send a written estimate to clients after they contact me with their request for a shoot. I ask them to provide a purchase order number to ensure that a go-ahead for the job has been approved on their side, and also ask them to return a signed copy of my estimate.

tip

The ASMP and other professional associations offer members sample business forms for estimates, delivery memos, and the like. Although they are generic and often need some customizing for a food photography business, they are a good starting point for developing your own paperwork tools.

Generally, I ask clients to advance 50 percent of the total estimate for the shoot to cover direct expenses, with the balance due on delivery of the final images. Clearly, one major advantage of digital photography is that photographers do not have to worry about film and processing costs, as they did in the past. This frees up a considerable amount of working capital that can be used for styling, props, equipment rental, and other expenses.

As with any business, there is a list of things you need to do to ensure your success. These include the following:

❖ **You need to choose a legal form of business.** You might be able to pick a corporate structure that gives your business a separate legal and tax identity from yourself. Discuss with a financial advisor whether you should operate as a sole proprietorship, a limited liability partnership, a limited liability corporation, a Subchapter S or C corporation, or some other entity. Of course, business structures can be changed if necessary. Talk with a good accountant and/or lawyer. Each type of corporate entity has different legal and tax consequences that you should understand.

Determining Your Corporate Structure

Often, new photographers set up sole proprietorships. This form of business is the easiest to start and gives you absolute control. The sole proprietor's income from the business is treated as personal income. The photographer does business as himself, which means that legally and for tax purposes, you are one entity.

In the beginning, this might make sense. But, as their business grows, people often explore the possibility of forming a limited liability partnership or "LLC." This gives your business a separate legal and tax identity from yourself. For example, in the unfortunate event that you are sued, the business assets can be taken, but not your personal assets. At the same time, profits from the business "flow through" directly to you, and are taxed at your personal rate instead of at a corporate tax rate.

This was an electronic postcard that I sent out for the 2004 holiday season. It was well received and helped generate business.

❖ **You must choose a business name and register it.** The name of a business is called a "trade name." Although the name of a company by itself is not a trademark, the name of the company may be trade-marked if it is used as the name of a product of service. You should consult an attorney to help you complete the process of registering. Often, states and counties will not permit more than one business to register the same name. When choosing your business name, check with a corporate name registration service to see if the same name is available.

❖ **You'll need to decide on your address.** Many photographers choose to use their home address as their business and mailing address, but others want to downplay the fact that they are a home-based business. I suggest using a post office or drop box as the business address.

❖ **Get a business license.** It gives you permission to do business in your area. Not every city or county requires a business license, but if your product or service is taxable, you will need a state sales tax permit and the business license.

❖ **Open a business checking account.** I suggest committing a full day to calling or visiting banks in your area to find out what services they offer. As you know, bank fees can be considerable, so shop around!

Saving for the Future

Unlike those in the corporate world, most photographers don't work for companies that offer retirement plans. It's important to think about the future. Small business owners have several options to choose from, such as self-employed 401(K), SEP-IRA, and SIMPLE IRA. All three have different features, so it is important to compare plans. In researching these options, determine the key advantages of each, as well as who is eligible. You also need to understand the funding responsibility, annual contributions, and limits per participant.

In the early years, if you are operating alone, it might make sense to go with the SEP-IRA. This plan is low-cost and low-maintenance. The other options usually are for people who have employees or a staff. Remember, your decision is sometimes linked to how you set up your corporate structure.

Additionally, note what access you have to the assets. You might find yourself in a financial situation down the road where you need to draw or take a loan from your plan, so check out the availability of funds and penalties for early withdrawals, if any. You also need to understand the vesting of contributions and the administrative responsibilities associated with your plan. Discuss your long-term goals with an accountant or financial advisor.

In closing, in matters of corporate structure and financial matters, it's important to seek the expertise of accountants and lawyers. Just like we have our craft, so do they.

Protecting Yourself

Every photographer and studio should have insurance, including property, general liability, health, disability, and workers' compensation. Your insurance needs to cover you out on location also, because equipment can easily be lost, damaged, or stolen. Many clients request to see a certificate of liability insurance to make sure the photographer is fully covered before working on their property. Be sure to find out your individual state requirements and shop around for the best prices.

Copyright Issues

One of the most important protections you can give your work is to register your copyrights. As a general rule, unless you sign away your rights, you own the copyright of an image as soon as you click the shutter. This gives you the right to license and relicense the image. However, you do not have the fullest protection of United States law unless you register your work with the Copyright Office. Registering your work makes a big difference in the event someone infringes on your rights and you need to pursue legal remedies. The process is not difficult, nor is it expensive, and it should be just as much a part of your post-production workflow as editing, retouching, and archiving your images. As this book goes to press in 2005, it is still necessary to fill out paper forms to register your copyrights. Online copyright registration is in development. The Copyright Office plans to have a system available in 2007.

tip

The ASMP has a step-by-step tutorial on registering copyrights, complete with annotated sample forms, at its Web site (http://www.asmp.org/copyright). It is available to members and non-members free of charge.

As you can see, success in digital food photography isn't just about being able to take great pictures. Creativity, teamwork, and passion are key ingredients, but it also requires a lot of business skill and attention to detail. It's been a great career for me, and I hope you will find success and enjoyment in it as well.

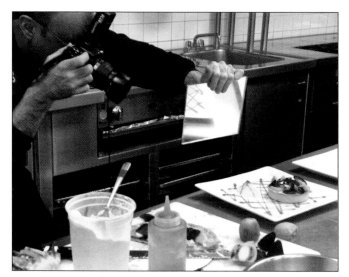

Index

Credits

Francesca Abbracciamento (Prop Stylist): 17B, 19, 27, 51, 55, 55B, 57C, 80, 81, 123, 132, 133, 148, 149, 206

Adrienne Abseck (Prop Stylist): 56B, 76B, 78, 79B, C

Momo Attaoui (Chef): Cover, 39, 43, 45, 59B, 83, 117, 120, 214-229, 230, 283

Betty Barquin (Prop Stylist): 4, 5, 10, 11, 12, 13, 17A, C, 18, 52, 72, 91, 124, 125, 126D, 128A, 130, 146, 147, 150, 151, 152, 153, 162, 202B, 205, 268, 269

Wayne Harley Brachman (Chef): xiiiD, 186, 187

Tina Marie Casaceli (Chef): 168, 169, 288

Tom Colicchio (Chef): 73

Anne Dawson (Prop Stylist): 144, 145, 154, 155, 156, 157, 194, 200

Franck Deletrain (Chef): 62

Alex Dzieduszycki (Chef): 75B

Chris Enright (Chef): 239

Dave Evans (Photographer): 4C,D, 10C, 12B, 90A,D, 126D

John Fraser (Chef): 9

Lynn Gagne (Food Stylist): 5, 10, 12, 13, 17C, 18, 52, 72, 91, 125, 130A, C, D, 147, 150, 151, 152, 153, 202B, 205, 268, 269

Sarah T. Greenberg (Food Stylist): 135, 199, 207

Justin Haifley (Chef): 161B, C

Henry Haller (Chef): 3C, D

Richard Hamilton (Chef): xiiiC, 68

Lisa Homa (Food Stylist): 17B, 19, 27, 51, 55B, 57C, 80, 81, 132, 206

Matthew Kenney (Chef): 74, 182, 183

Marian Laraia (Chef): 71C, D

Richard Leach (Chef): 87, 88D, 188, 189

Michael Lomonaco (Chef): 1, 121

Rodney Mitchell (Chef): 232

Neil Murphy (Chef): 89, 163

Reid Nicholls (Photographer): 75A

Samia Patel (Food Stylist): 88E, 193, 197A

Morgan Poor (Photographer): 57B

Brian Preston-Campbell (Food Stylist): xiiiB, 8, 32, 33, 53, 58A, 67, 69, 70, 71, 76B, 82, 94, 95, 96E, 97, 100, 101, 104, 106, 107, 114, 115, 116, 123, 127B, 133, 139, 158, 159, 160B&C, 162, 172, 173, 210, 244-265, 278

Marco Runanin (Chef): 184, 185

Joyce Sangirardi (Food Stylist): 76A

Bruce Schlesinger (Photographer): 16

Ilene Shane (Chef): 75C

Jason Silverman (Prop Stylist): 58B

Suzie Skoog (Food Stylist): 21, 144, 145, 155, 156, 157, 200

Kristin Slaby (Prop Stylist): 59B, 67, 69, 76A, 83, 88E, 131, 135, 138, 139, 162, 193, 197A, 199

Micki Stolker (Food Stylist): 58B

Kathy Stromsland (Prop Stylist): 59A, 127B

Ben Swanger (Illustrator): 160, 161, 195, 196, 197, 202, 203, 211, 241

Ian Topper-Kapitan (Chef): 164, 176, 177, 178, 179, 180, 181

Matt Tuttle (Prop Stylist): 126A, B, C, 127C, 128B, C, 129

Diane Vezza (Food Stylist): xiiiA, 29, 56B, 63, 66, 78, 79, 92, 93, 96A,B,C,D, 98, 99, 102, 103, 105, 108, 109, 110, 111, 112, 113, 118, 119

Brian Watterson (Photographer): 88C, 288

Jay Weinstein (Chef): 47, 122, 140, 141, 142, 143, 160A, 161E, F, 162, 165, 166, 170, 171, 174, 196, 208B, 231, 233, 235, 237, 285

Bill Yosses (Chef): 137

Fran Zaccaria (Chef): 71, C, D

Terese Zaccaria (Chef): 71, C, D